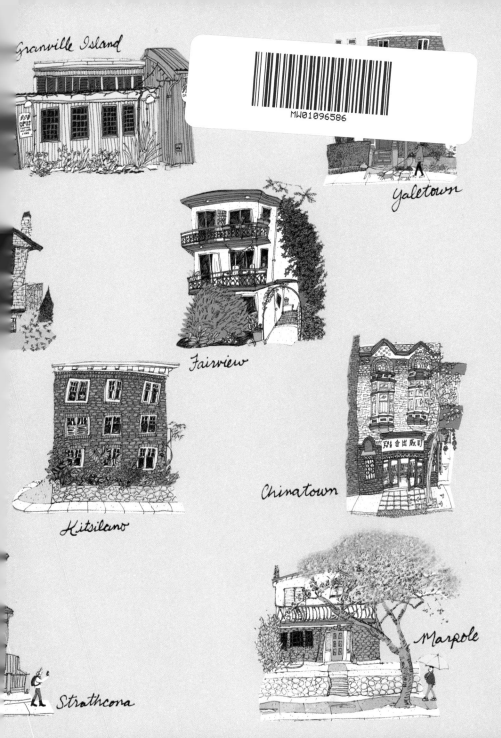

Granville Island

Yaletown

Fairview

Kitsilano

Chinatown

Marpole

Strathcona

Hand Drawn Vancouver

Sketches of the City's Neighbourhoods, Buildings, and People

EMMA FITZGERALD

appetite
by RANDOM HOUSE

I dedicate this book to my parents,
Trish and Mark FitzGerald, who brought
me to Vancouver in the first place.
And to all the teachers I found here—
there have been so many of you.
Thank you.

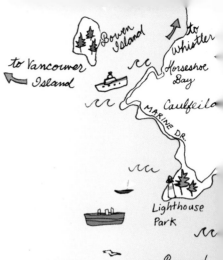

Pacific Ocean

VANCOUVER

Burrard Inlet

to Vancouver Island

to Whistler

Bowen Island

Horseshoe Bay

Caulfeilo

MARINE DR.

Lighthouse Park

JERICHO BEACH

WILDERNESS BEACH

KITS BEACH

Kits Pool

N.W. MARINE DR.

WRECK BEACH

U.B.C.**

Point Grey

Kitsilano

WEST SIDE

Dunbar—Kerrisdale
Southlands
Musqueam
First Nation

S.W. MARINE DR.

The sketches in this book
were completed on and represent
places in the traditional and
unceded territory of the Coast Salish
Peoples: the Squamish, Musqueam,
and Tsleil-Waututh First Nations.

to Seattle

Sea Island

RICHMOND

YVR AIRPORT

Capilano Water Shed

the Lions / Twin Sisters

Upper Levels CYPRESS

GROUSE MOUNTAIN

North Shore

MOUNT SEYMOUR

WEST VAN

Edgemont Village

NORTH VAN

Lynn Valley

Dundarave

Ambleside

Capilano River

MARINE DR

Capilano River Reserve

Lower Lonsdale

Lonsdale Quay

Tsleil-Waututh Nation

Deep Cove

Third Beach

Stanley Park

Canada Place

Vancouver Harbour

English Bay

DENMAN ST

West End

Coal Harbour

ROBSON ST.

Crab Park

Hastings-Sunrise

BURNABY

DOWNTOWN

Yaletown

Gastown

DTES*

E. HASTINGS

Granville Island

Olympic Village

Chinatown Strathcona

Hogan's Alley

COMMERCIAL DR.

BOUNDARY ROAD

South Granville

BROADWAY

Fairview

CITY HALL

Mount Pleasant EAST VAN

Shaughnessy

Cambie Village

the FRASERHOOD

TROUT LAKE

Granville St.

41st

Cambie St.

Riley Park

MAIN ST.

KINGSWAY

Marpole

SOUTH VAN

Little India

Fraser River

SE. MARINE DR.

*Downtown Eastside
**University of British Columbia

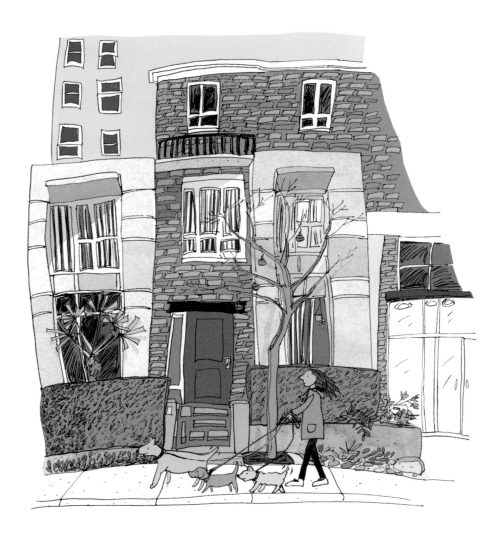

A dog walker takes her three charges on a stroll through Yaletown.

CONTENTS

Inside the Kits Food Market.

INTRODUCTION

I moved to North Vancouver aged seven. I was no stranger to moving by the time we arrived, so it wasn't a surprise when soon after settling in, we moved again to West Vancouver. Or that I later attended high school on the west side of Vancouver, all the way over two sets of bridges.

My daily commute to school, an hour each way in the backseat of the car, was an education in the geography of the city. We passed through Dundarave and Ambleside, stalled in traffic at Park Royal, went over the Capilano River Reserve while crossing the Lions Gate Bridge, and then were momentarily surrounded by trees in Stanley Park. It was often a quick drive through the West End and Downtown, seemingly before anyone else was awake, then over the Burrard or sometimes Granville Bridge, through Kitsilano, all the way to Dunbar—only to do it all in reverse at the end of the day. Looking out of the window, I discovered that each neighbourhoood had its own unique architecture and population, and they became endlessly interesting to me.

Later, while studying Visual Art at the University of British Columbia, just past Point Grey, I spent more of my free time on Commercial Drive and Main Street. I taught art classes on Granville Island and in Strathcona, and even painted a mural in Hastings Sunrise. The more I explored Vancouver, the more my understanding of it grew.

After my undergrad I moved to Nova Scotia, where I wrote and illustrated two books based there. Returning to Vancouver after fourteen years of living away, I relearned the city in the process of making this book. Instead of visiting an archive, my research was conducted on the city's streets, with pen and paper in hand. Sketching on location is a way of learning a place—not just its sights, but also its smells and sounds as the world continues its hum around me. I was drawn to places where

community naturally forms, as well as the places that had left a mark on me, knowing that if they had survived the passage of time, they must be special to others as well.

I colour my drawings later, digitally, and excavate both my notes and my memories for text. Some of the stories you'll read in this book are from the people I've met while sketching, or snippets of conversation I overheard. I've tried my best to respect the people and places I have portrayed, and I acknowledge that any mistakes are my own.

For some, Vancouver is a place you can ski and sail in the same day. For me, it's a place I can eat a steamed bun from a Chinese bakery while watching the sunset on the Pacific, swim with harbour seals within view of the city's glass skyscrapers, and wander through back lanes and beaches.

Whether you are a visitor or resident, I hope that you see some of "your" Vancouver in this book, and take it as an invitation to make more of your own discoveries in this remarkable city.

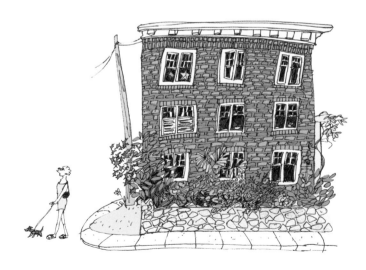

Beachfront apartments in Kits with lush gardens make for dreamy homes.

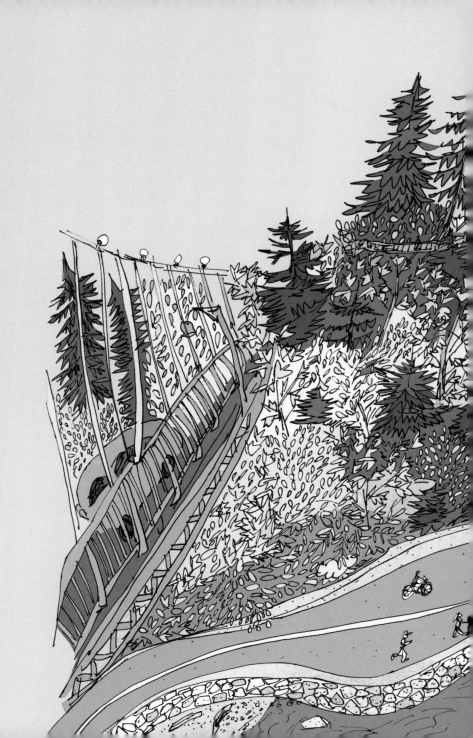

DOWNTOWN

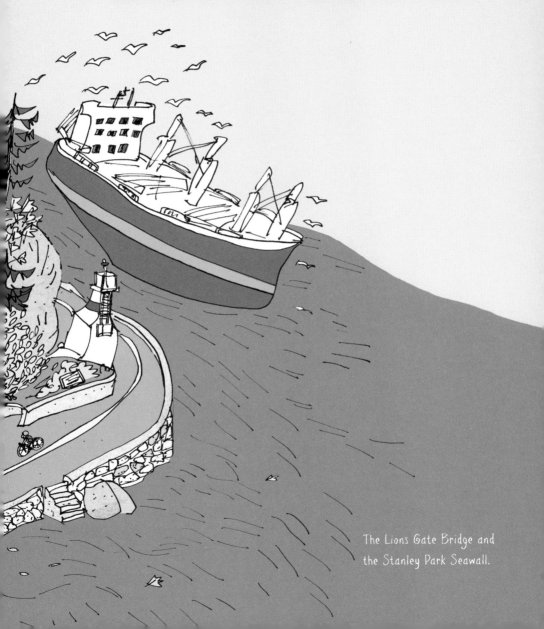

The Lions Gate Bridge and
the Stanley Park Seawall.

COAL HARBOUR

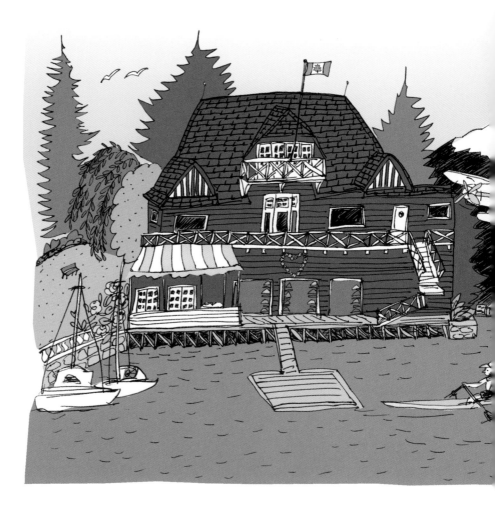

There are many transportation options in Coal Harbour—like floatplane, yacht, or rowboat—or you can head out on foot or by bicycle around Stanley Park Seawall. This morning, preparations are underway for a wedding at the Vancouver Rowing Club. The sun rises, casting a rosy glow on the North Shore mountains.

WEST END

At English Bay, a trio plays the jazz standard "What a Wonderful World," and a passerby starts to sing along. I agree—that is, except for the minor irritation of some ants. Seemingly in search of a picnic, they crawl up and down my arm as I sketch. In the distance, Bard on the Beach tents are readied for an evening of performances, and the barge for summer fireworks stands ready in the water.

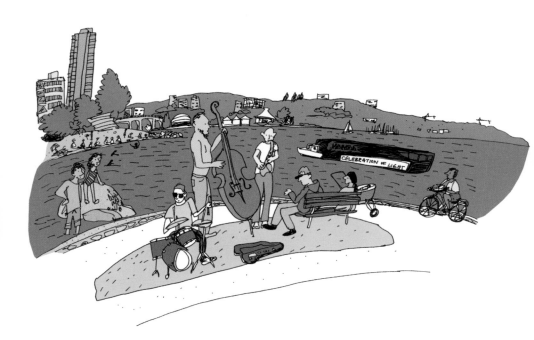

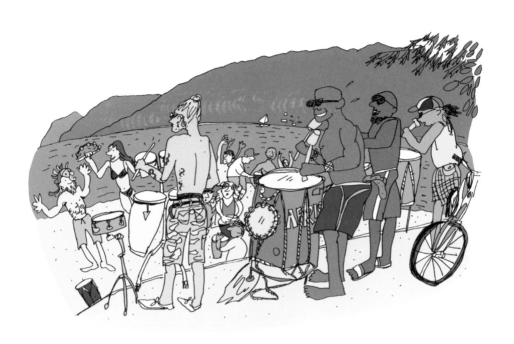

On Tuesday nights in the summer, Stanley Park's Third Beach hosts the largest drum circle in the city. Participants wear a broad range of outfits, from bathing suits to wild costumes—I initially sit beside a reclining mermaid. I relocate to distance myself from a thick cloud of patchouli, and sit on a small stool on the seawall for a better view from behind the lead drummers. Police officers on horseback keep a path clear on the seawall, where the crowd is up to eight people deep.

The Sylvia Hotel, its walls thick with Virginia creeper, is named for Sylvia Goldstein. Her father, Abraham Goldstein, emigrated from Poland and had the building built in 1912. At eight storeys, the hotel was the tallest building in Vancouver's West End until 1958.

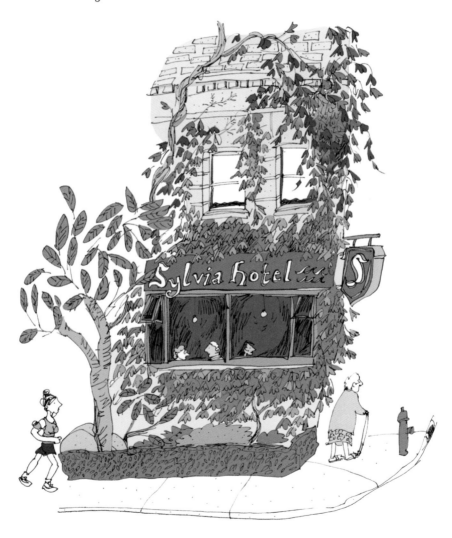

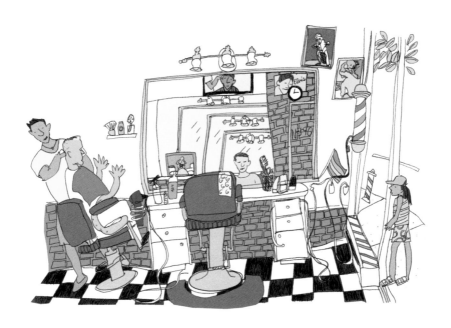

"Papi, Papi, can we go to the beach now?"

A young girl waits for her uncles and grandfather to get their hair cut at Cut My Hair Barber Shop, on Denman Street. The uncles, all from Chile, converse in Spanish, while the owners chat in Arabic. It will be a little while longer before they can head down the street to the beach.

The colours of the community garden at the corner
of Burrard and Davie are an extension of the
street's rainbow-coloured banners, which
celebrate the West End as a welcoming
place for Vancouver's LGBTQ+ community.
The garden was once a gas station.
Now, the only remaining gas station
downtown is across the street beside
Celebrities, the famed nightclub. I go
next door to Vera's Burger Shack,
remembering the days when I used to
eat burgers made by Vera and her
sister at their concession stand on
Dundarave Beach in West Van.

 While ordering a classic Vera
Burger, I say to the server, "You know,
Vera was a real person," remembering her
in her hot, cramped shack on the beach.
That was twenty-seven years ago, though,
long before Vera's became a franchise. The
woman smiles at me politely, but not as though she
believes me. "Would you like a beer with that?" she
asks. I say yes, suddenly feeling just a little bit old.

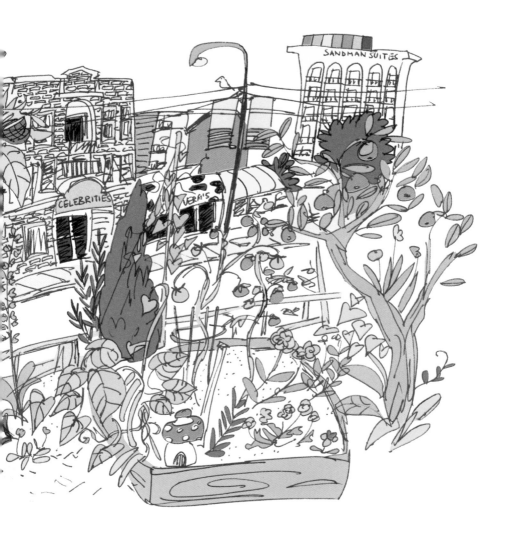

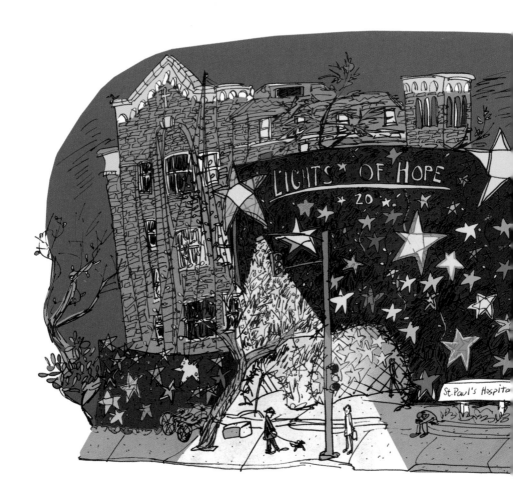

DOWNTOWN

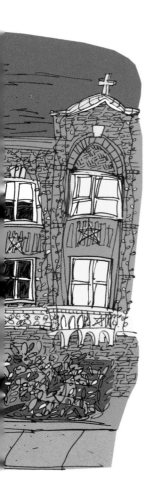

In the weeks leading up to Christmas, St. Paul's Hospital's annual Lights of Hope campaign makes for a sky full of stars on the building's facade.

The Vancouver Art Gallery on Robson Street has become a central reference point for me, and I always try to see the shows on exhibit. But what happens outside the gallery is just as important. You might find protests, old folks playing chess, people ice skating, kids hanging out, and art of all kinds. I hope the VAG's new home is just as active when it moves in a few years.

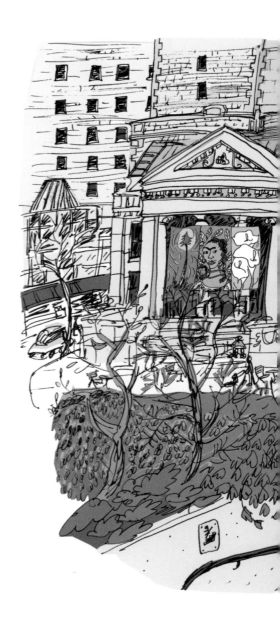

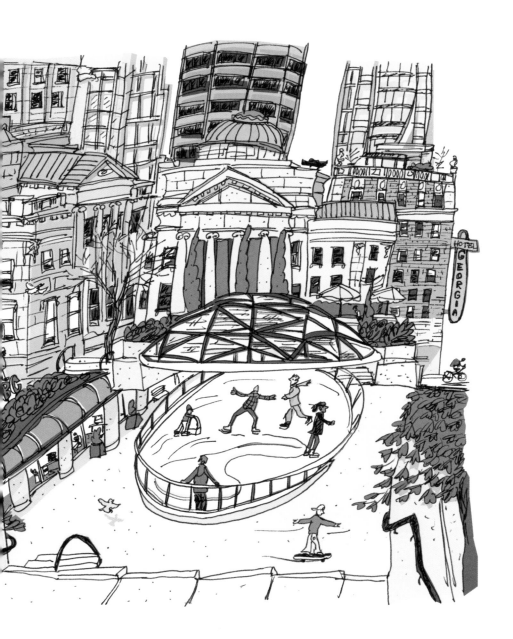

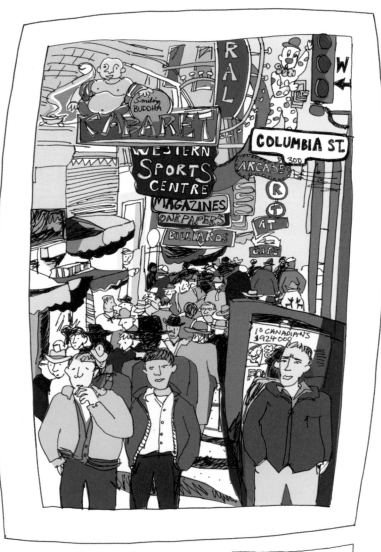

untitled
(Hastings at Columbia)
1958 Fred Herzog

"Sarah, Rhonda, Frances . . . Angela . . ." calls out the voice of performance artist Rebecca Belmore in a video on display at the Vancouver Art Gallery. Just around the corner is a series of Fred Herzog photographs, including the well-known "Untitled (Hastings at Columbia)," a colour photo taken in 1958 in the Downtown Eastside. Rebecca's performance is an ode to missing and murdered Indigenous women. Many have disappeared just blocks from where Herzog's photo was taken. Called "Vigil," the piece was filmed by Paul Wong during the Talking Stick Festival in 2002.

I look at Herzog's photo, which is mostly devoid of women, except for some faces on the daily paper's front page. The video loops back to its beginning, and I hear the song "It's a Man's Man's Man's World" playing.

Burrard Station becomes Cherry Blossom Central in the month of April.

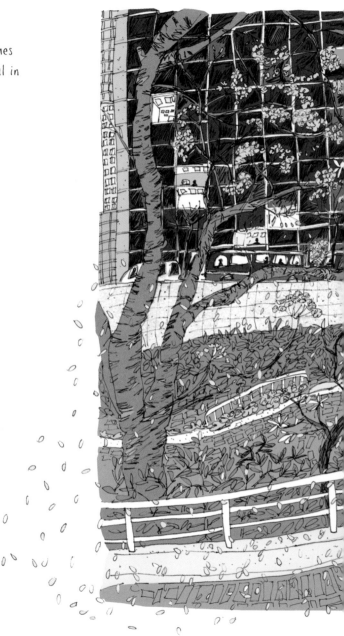

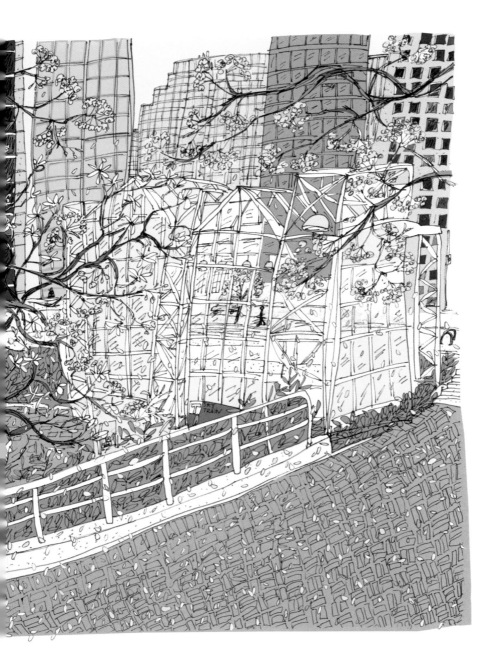

As the rest of the country shovels snow, Vancouver's streets are cleared of Neapolitan ice cream-coloured drifts of cherry blossom petals.

Built in the late 1920s, the Commodore Ballroom's art deco-styled windows have seen many fashions parade along Granville Street, from the fur stoles of the Dirty Thirties to the raver fun-fur of the '90s.

Inside, the music has been equally diverse. Audiences have enjoyed artists like U2, Nirvana, and the Village People from the sprung dance floor, lined with horsehair to lessen its impact on people's feet.

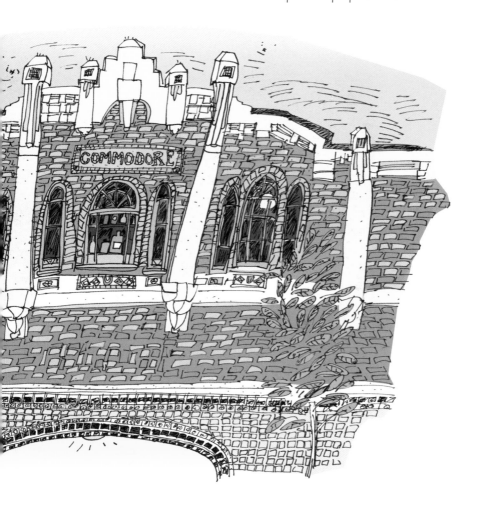

Harbour Dance Centre, on Granville Street, offers adult recreational dance classes, from hip hop to salsa. The studio's open atmosphere means beginners and advanced students brush shoulders. The only prerequisite is making it up the steep flight of stairs to get to class.

At the start of ballet class, Danielle Clifford, co-founder of the studio, motions for a more experienced student to come to the front. "What is your name?"

"Hillary."

"Hillary!" she declares in her French accent, shaking her head. "Hmm, uh-oh, like you-know-who. Okay, we won't even talk about it!"

We aren't here to talk about politics. We are here to dance. And with that, class begins.

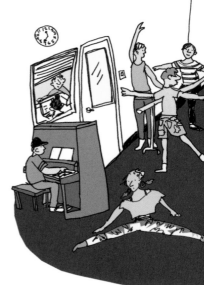

On the wall hang photos of the Anna Wyman Dance Theatre, a Vancouver-based modern dance company where Danielle once served as ballet mistress. The dancers toured the world in the 1970s and '80s. Anna, a living legend, has a star on the BC Entertainment Hall of Fame's StarWalk on the street below, which is visible from the barre as we plié and pirouette.

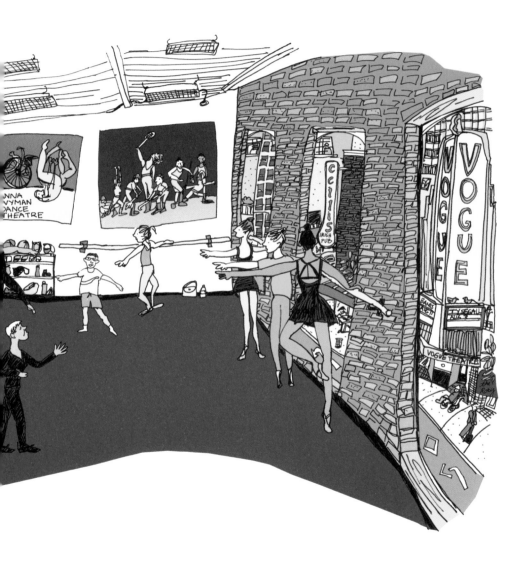

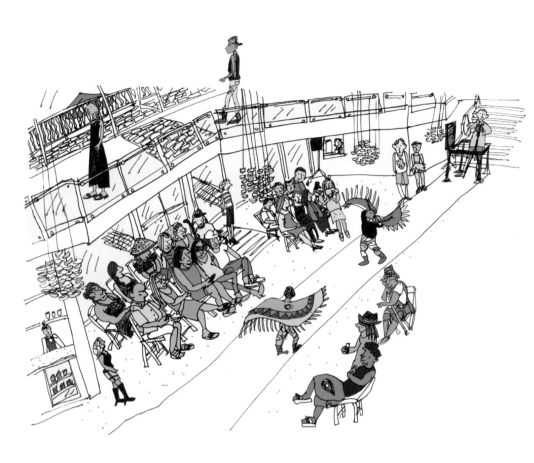

The inaugural Vancouver Indigenous Fashion Week is taking place at the Queen Elizabeth Theatre in the heart of downtown. Joleen Mitton, a Cree woman, founded the event, which brings together her background in fashion and her work with Indigenous youth. Whether the models are wearing street fashion, minimalist designs, or neon renditions of traditional dress, the message resounds that the bodies of Indigenous people matter—as do their aspirations.

Small restaurants side by side serve the downtown working lunch crowd. Take your pick: donair, Vietnamese pho, Indian curry, or Japadog's Japanese-style hot dogs.

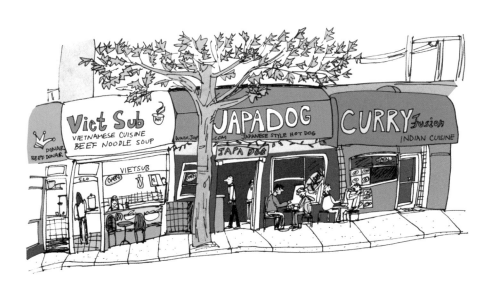

The Vancouver Central Library sits against a crisp blue sky, its architecture reminiscent of the Colosseum in Rome. However, when paired with a pumpkin latte billboard, suddenly its warm hue and rounded shape give it a vegetal resemblance, and for a moment, it is positively pumpkin-like.

Gardens have always been part of the library's design. Its rooftop, a green garden designed by acclaimed landscape architect Cornelia Oberlander, is planted with grasses that don't need cutting or fertilizing, in a design inspired by the shape of the Fraser River. Visible from neighbouring condos but not accessible to library patrons until recently, as it was only after the library's 2018 expansion that its gardens became public.

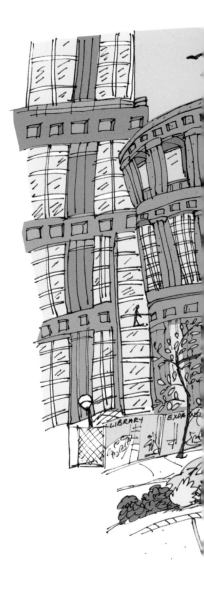

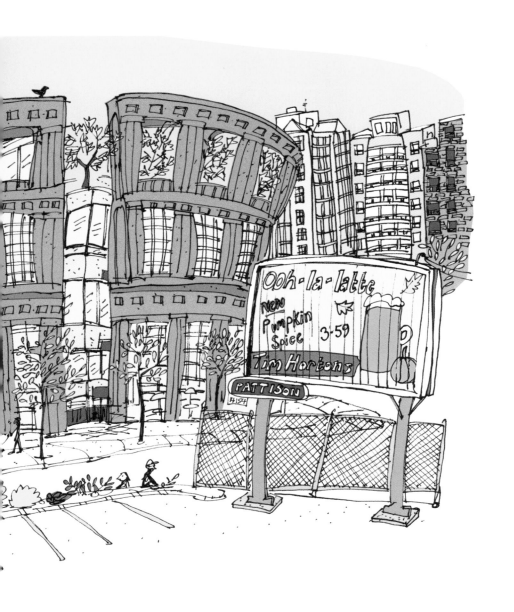

The sign reads:

Ooh - la - latte
New Pumpkin Spice 3-59
Tim Hortons
PATTISON

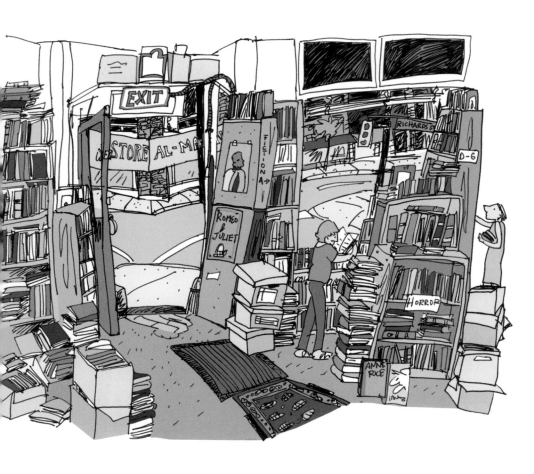

Paris has Shakespeare and Company, New York has the Strand Book Store, and Vancouver has MacLeod's Books. On a hot summer day the heat is suffocating, but a fan makes a valiant effort to cool the patrons browsing the dizzying array of books.

"The great cool-down is coming this weekend," says Don Stewart, a now white-haired man who has owned the store since the age of twenty-one. "The rain is coming."

Hannah H. of Charlottesville, USA, has this to say about the shop on Yelp:

"Easily the most magical, musty, maze-like bookstore I've ever visited. A haven for old souls, hard-core bibliophiles, or even simply tourists looking for ways to kill time (I happened to be all three). Came away with a wonderfully eclectic selection of titles, from Dickens to Haruki Murakami, Bukowski, Chaucer, and (squee!) a hardcover first edition of Percy Shelley's collected poems, with a calligraphic inscription written from a young man to his lover, dated 1822."

I'd say the well-trod threshold is sufficient evidence that a trip inside is worthwhile.

"Hi there. You're drawing that building, are you?"

"Yes, it interests me. Do you know why they have those screens in the windows?" I point to the hostel windows above Finch's Tea & Coffee House, at West Pender and Homer.

"Oh, that's so they don't throw shit out the windows. Have you been to the Hendrix shrine? It used to be down at Main Street and Union. Had to move up here—the building's being torn down."

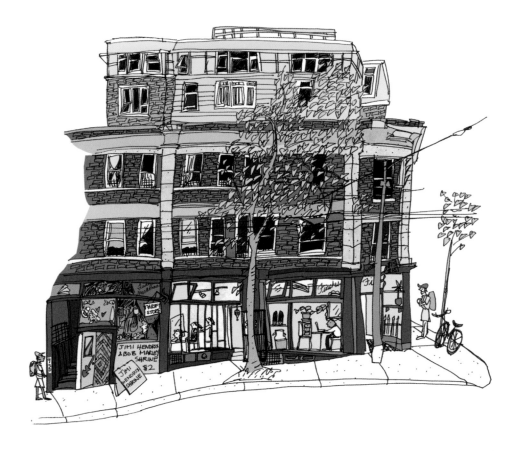

GASTOWN

As I sketch, a tourist just off the Rocky Mountaineer says, "You've got the best picture here—no people in it!"

It is true; none of the many tourists photographing the clock are in my sketch.

"I thought I'd add them in after."

"Oh no, I wouldn't crowd it."

A busker behind me sings, "Here Comes the Sun . . ." Meanwhile, here comes the steam. The clock strikes on the quarter hour, whistling.

"Everyone loves that clock," says a local walking by. "I just don't get it."

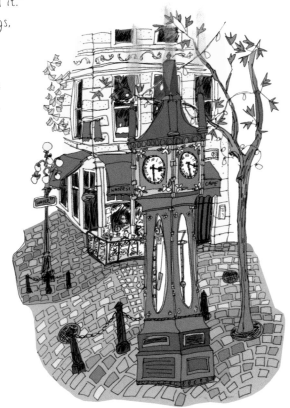

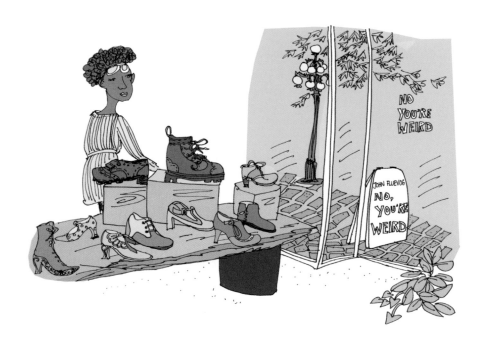

John Fluevog Shoes' Gastown location is a block away from the Fox and
Fluevog store where John got his start as a shoe designer in 1970. I
overhear a woman eyeing a particularly fantastical pair. "I saw these last
year, but I didn't buy them—I was trying to be practical." My bet is that
she might not resist this year.

At the corner of West Hastings and Cambie you'll see the brightly hued Dominion Building (built in the Beaux Arts style between 1908 and 1910), Marc Emery's Cannabis Culture and the New Amsterdam Cafe, a vacant lot, and a record store, with the new Woodward's building visible behind. They all combine to create a kind of crazy-quilt pattern to rival any of the fabrics found at the fabulous Dressew Supply Ltd., touted as "your selection store."

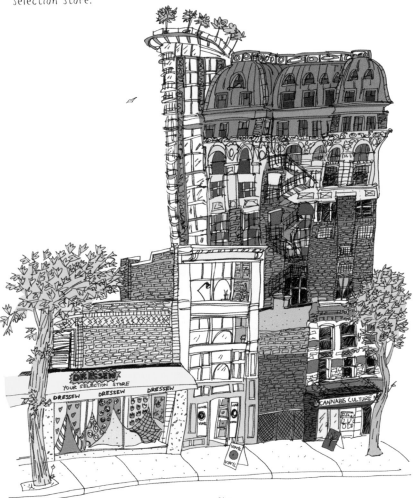

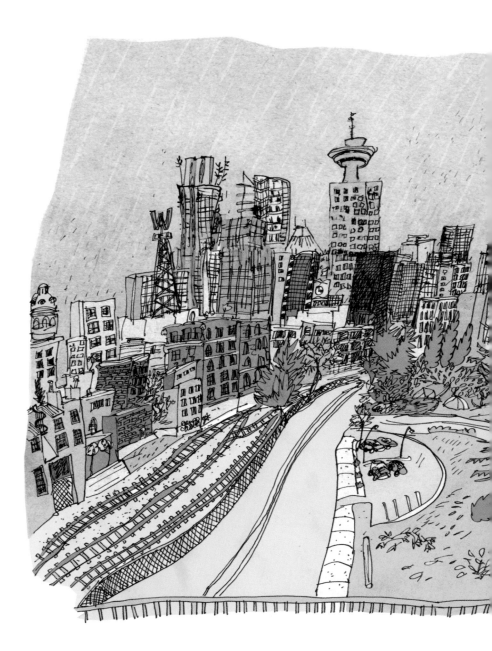

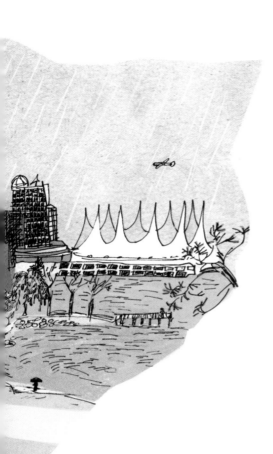

On a dreary day I draw a view of CRAB Park and the railway tracks below. In the distance, the Teflon-coated fibreglass sails that make up the roof of Canada Place stand tall like stiffly peaked meringues.

DTES *

*DOWNTOWN EASTSIDE

I go to the Downtown Eastside to sketch Main and Hastings with David
Love, an author and long-time resident of the area. Carnegie Community
Centre is open every day of the year. The building houses the Carnegie
library branch, an affordable cafeteria, an art space, and, most
important, a safe space for the many homeless people in the area.

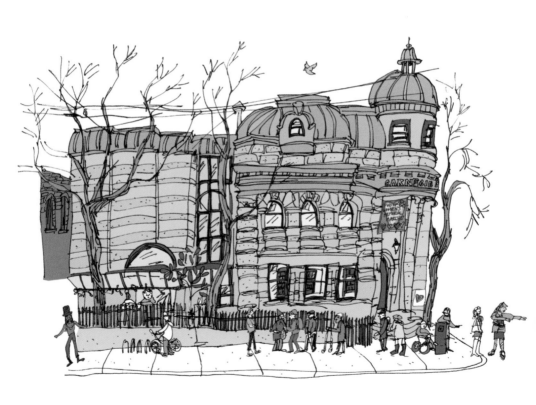

"Are you girls hooking tonight?" asks a trans woman wearing a wig, fake eyelashes, and heels at a bus stop on East Hastings.

"Nope, we're just heading home. Glad it stopped raining," answers my friend Eryn, as though the question had been about the weather. We had been gallery hopping and were wearing the art scene uniform of black skinny jeans and raincoats.

"Oh yeah, the rain. We've really needed it, but it's humid now. I'm living at the women's shelter up there, on the top floor. I was putting on my makeup tonight and it was all melting right off . . . I guess we're lucky we aren't dealing with Hurricane Irma, or that earthquake in Mexico." Gesturing at the dress and heels, "You know, I never thought I'd be doing this. I've been rich, I've been poor, I've been a pro golfer, and I've been to Hawaii, and Las Vegas, too. All I ever wanted was to live until I was thirty, and I'm thirty-eight now."

"I think you have a few years left in you!" says Eryn.

"Maybe, but you know, my dad died when he was twenty-nine. I had to bring up my siblings myself, so I've already done that raising-kids thing. I figured I would just live until I was thirty and that would be it."

Our bus comes and, with a "Have a good night," we head our separate ways. I am not sure if I'll remember any of the art I saw that evening, but I will remember our chat at the bus stop.

A fig tree across from the Sunrise Market grocery store, at Powell and Gore Street, stops me in my tracks. In full fruit, it almost completely covers Ask For Luigi, one of many fine-dining establishments that have sprung up in the area. I sit on the facing corner and I start to draw, beginning with the fig tree.

Someone passes by and gives some feedback: "Those look more like oak leaves."

I realize that yes, my fig leaves look more like oak leaves. I start again.

I look closer. I see I am not the only one drawing. Sitting on the facing curb is a man scrawling intently on paper. Is he drawing me? I add him to my drawing.

Twenty minutes later, he crosses the street and shows me two drawings: one of a duck and one of a ship, both finely crafted in pencil. The artist's name is Don Bodeck, and he hails from Newfoundland. This has been his gig for some time, making drawings on street corners and selling them. I only have six dollars in my pocket, but I give it to him for the drawing of the boat. "That's great," he says. "Now I can get to Nesters Market before it closes and get a roast chicken." With that, he is gone.

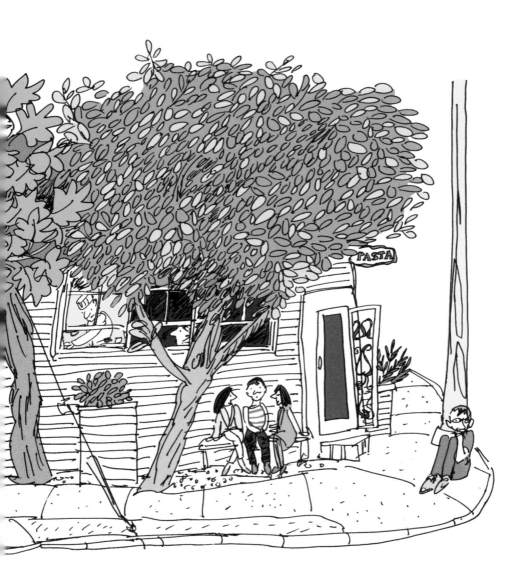

CHINATOWN

A gingko tree drops golden yellow leaves in front of Sino United Publishing's red-and-white-painted storefront in Chinatown. Gingko trees survived the Ice Age and have been used medicinally to improve memory.

Across the street, a woman paints the base of a condo building. She stops to make a call to the building superintendent. "I want to make sure I have the right grey."

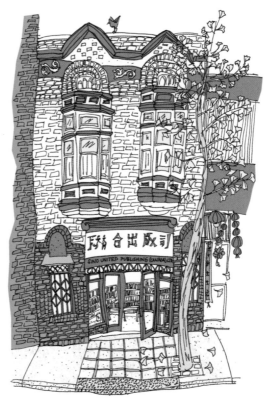

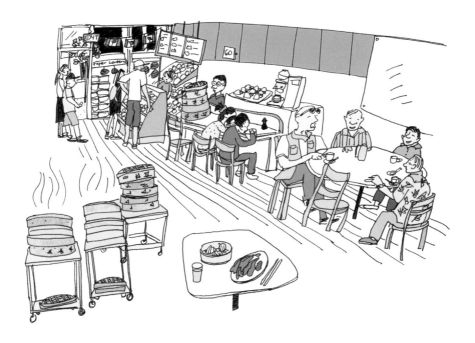

"What about me?" asks my server as I sketch at the very busy New Town Bakery in Chinatown. Then she laughs and says, "You should draw my boss, Susanna."

She gestures to a woman in glasses behind a tower of steaming buns, kept warm in their baskets. I grin and go for it.

"Oh!" she laughs. "You made her look too white."

As she leaves to attend to another customer, I try again.

She returns, and this time she grins. "Yep, that's Susanna."

Nearby sits a circle of gentlemen. Their meals are long gone, but their tea and conversation are still going strong.

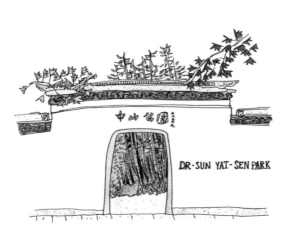

DR-SUN YAT-SEN PARK

This doorway extends an invitation to go inside the Sun Yat-Sen Park, located next to the famed Dr. Sun Yat-Sen Classical Chinese Garden, and see more.

Free of charge and open most days, the park is a discovery worth making.

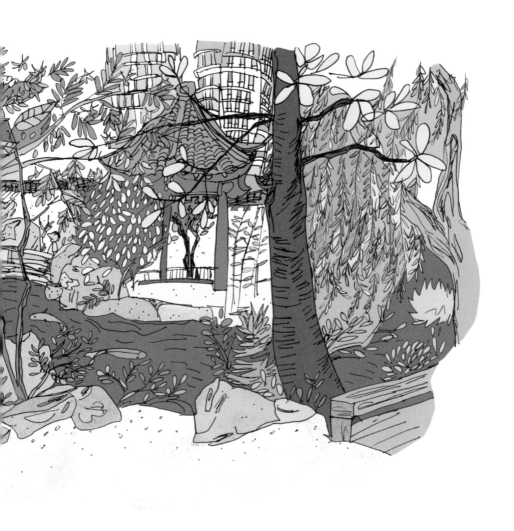

Inside the Sun Yat-Sen Park it is cool and calm.

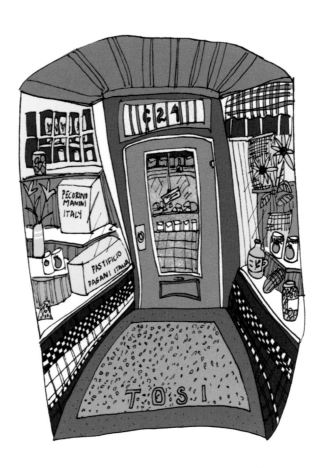

Tosi is an Italian food store right in the middle of Chinatown at 624 Main Street, and it's over a hundred years old. Although it will close soon, when aging owner Angelo (the son of its original owner) retires, it is still open when I visit on a sunny Saturday. To gain entry, one must follow instructions written in English, Italian, and Cantonese. Inside it is cold and dimly lit, but customers are rewarded with vats of black olives, foods straight from Italy, and all the seeds needed to create an Italian garden, with many varieties of radicchio and basil.

I buy some smoked herring. "What you gotta do with that," Angelo says, "is you take it home and you boil the shit out of it with some garlic, and put it on pasta. *Mamma mia*, heaven."

His accent is not Italian, since he grew up in the neighbourhood, but his voice has the singsong cadence of that language.

He gestures towards Keefer Street. "There used to be Russian Jews up there. They had a hardware store, a violin shop. They'd play violin on the loading dock of their truck. And up the street you used to get the best Spanish coffee—you know, the kind with some booze in it."

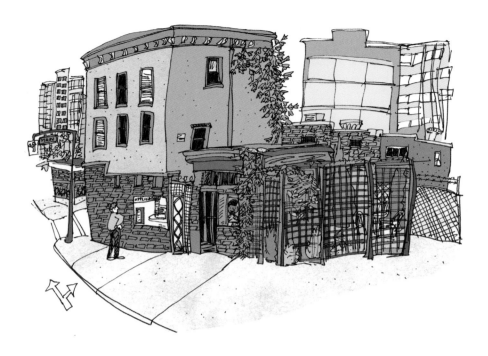

What is now Main Street and Union Street used to be Hogan's Alley, a black community near the (still existing) train station, where many black men worked as porters on the trains. Some of the original black settlers in BC who had farmed on Salt Spring Island moved there. The neighbourhood was razed in 1970 to make way for the Georgia Street viaduct, which will also soon come down.

The only structures left from Hogan's Alley are a blue building on the corner that is said to have been a boarding house, and a small brick building that was adjacent to the famous "Vie's Chicken & Steak House" where Jimi Hendrix's grandmother Nora used to work. Jimi used to come up from Seattle to visit. Later, there was a Jimi Hendrix shrine at the site, but both buildings were slated for demolition as I drew. In a victory for the community, affordable modular housing has been built since the demolition, named "Nora Hendrix Place" to honour her memory.

"And now, if you want to make this move very expert," says yoga teacher Fabiola at Chinatown's STRETCH yoga studio, pausing for effect, "you can smile while you do it."

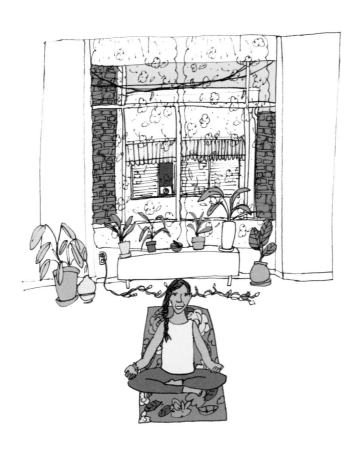

YALETOWN

I learned enough linear algebra to grasp the basic concept of the x, y, and z axes, a tool for mapping information in space (and not a reference to Generation X, Y, or Z). I can't stop thinking about x, y, and z as I walk through Vancouver. The 99 B-Line bus, the 10th Avenue bike corridor, and the nightly crow commute travel east and west on the x axis, while the bridges carry traffic and rivers carry salmon north and south on the z. Building foundations dug into the earth and rebar pushed upward to make skyscrapers complete the y axis, following the same impulse as a cedar tree's roots and trunk.

I think about all this as I sketch the foundation of a building at the edge of Yaletown, with the new casino still under construction beyond. The casino is clad in bronze, which looks like armour, with plywood and scaffolding filling in the cracks. Above me, a group of crows appears more as a languorous constellation in the sky than a murder, a slow eastbound apparition that occurs every evening in Vancouver. Behind me, a man says to a friend, "There they are, the crows are on the move. They'll be headed up to the rookery at Still Creek, in Burnaby. They used to go somewhere else, but something changed . . ."

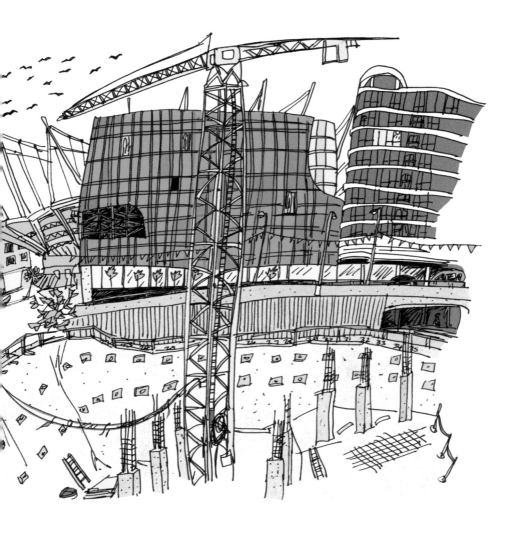

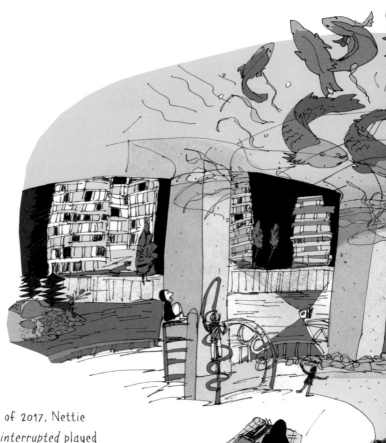

In the summer of 2017, Nettie
Wild's film *Uninterrupted* played
almost nightly under the Cambie
Bridge. By season's end, it had been
seen by approximately thirty thousand people.
In bringing art to Coopers' Park in Yaletown, Wild
overcame the eternal summer dilemma of Vancouver's arts scene: on a warm
evening no one goes to shows; they'd rather be on the seawall. The crowd,
hushed and closely gathered, watches with reverence as the life cycle of a
wild salmon is projected onto the concrete underbelly of the bridge.

I wonder how many people come to claim their umbrella at the Stadium SkyTrain depot's lost and found?

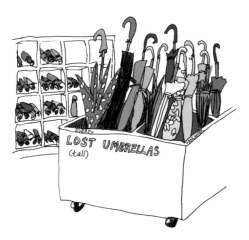

LOST UMBRELLAS
(tall)

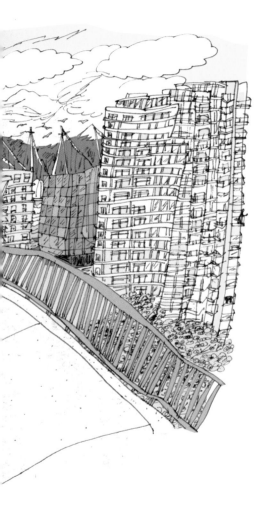

I've noticed in my travels that regions paint their highway infrastructure to match their landscape. In New Mexico, the roadway structures are painted a chalky pink to match the colour of the earth, a subtle but appreciated co-ordination. Going over the Cambie Bridge, I notice the same strategy seems to be at work: the railings and light fixtures are painted a green-blue teal that complements the mountains and glass-faced buildings on a clear day. However, when the rain comes, or smoke arrives from summer forest fires in BC's interior, the city's colour palette changes rapidly.

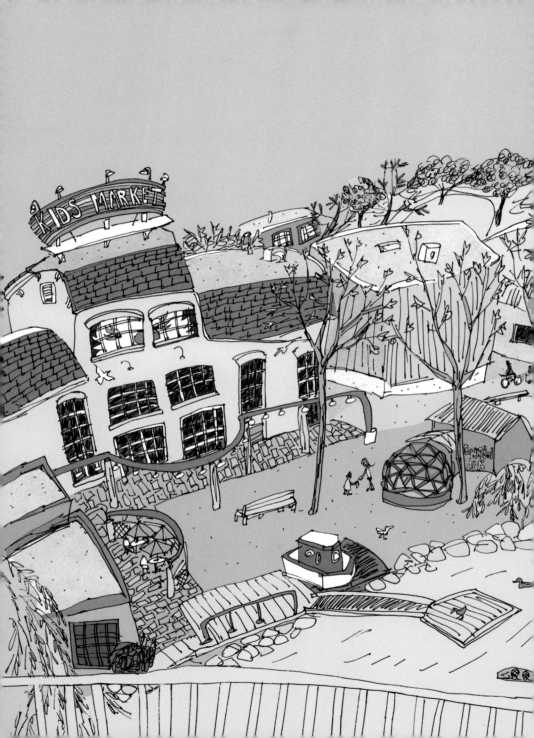

WEST SIDE

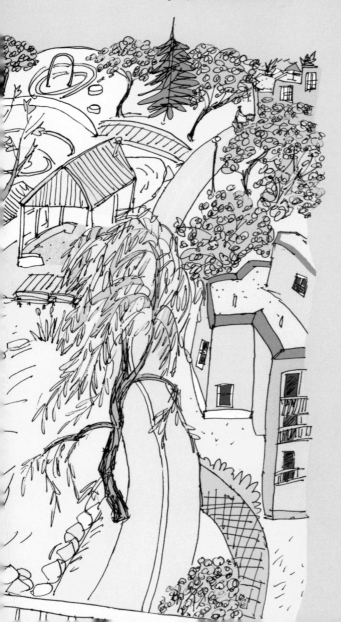

Granville Island's
Kids Market.

GRANVILLE ISLAND

Opus Art Supplies is a fixture for artists working on Granville Island and beyond. I sit in front of the former campus of Emily Carr University of Art + Design, eerily devoid of art students after the school's recent move. Inside the store you can find any number of paint colours including, but not limited to, Citrine Yellow, Marseille Yellow, Saffron Orange, Coral Red, Scarlet Red, Ruby Red, Opaline Pink, Garnet Red, Etruscan Red, Parma Violet, Lapis Blue, Ming Blue, Sapphire Blue, Malachite Green, Olivine Green, Bronze Green, Peridot Green . . . all vying for attention.

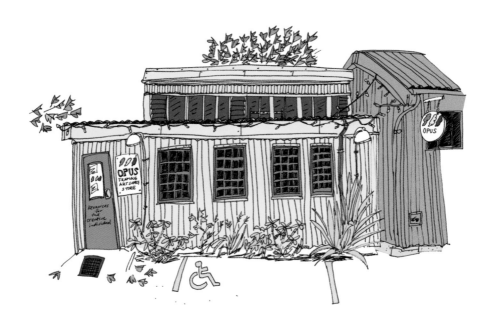

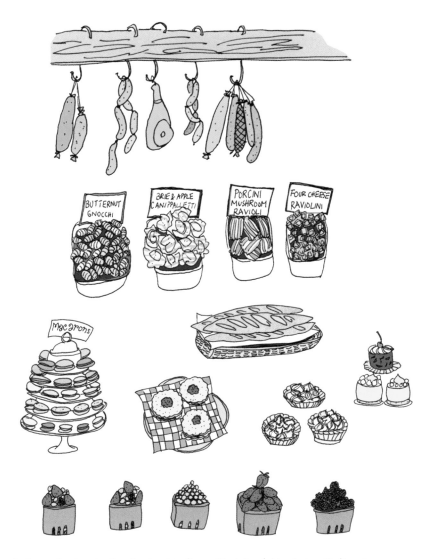

A few minutes in the fantastic Granville Island Market will dispel any notions that *all* Vancouverites are vegan and gluten-free, though the selection of fruit and veg is great too.

S. GRANVILLE

Monet meets McDonald's at Broadway
and Granville Street as a B-line bus
pulls in, advertising the current show at
the Vancouver Art Gallery. All summer, it
created winding lines around the building on
pay-what-you-can Tuesday evenings. I find
this written by a gallerygoer in the "I Saw
You" section of the *Georgia Straight*, the
city's weekly entertainment paper:

"You left an impression. Friday afternoon
in the Monet exhibit at VAG, you were
with an older woman, I with a younger. We
crossed paths, eyes, and smiles a few times;
you stood next to me as we took in one of
Monet's more abstract pieces ('Japanese
Bridge'). I'd love to hear what you thought
of the piece, as well as to see your smile
once more. Coffee, a bike ride, an art
exhibit? Let me know."

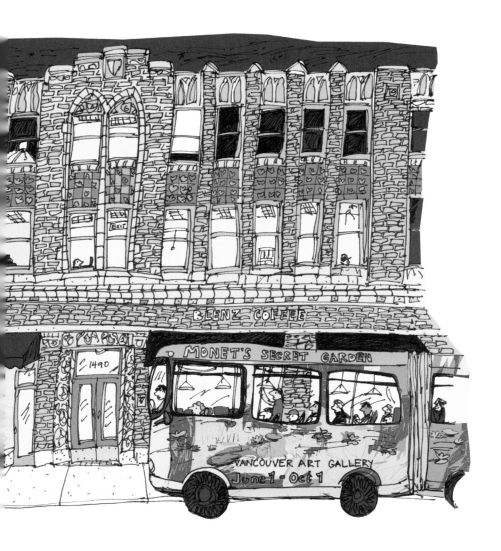

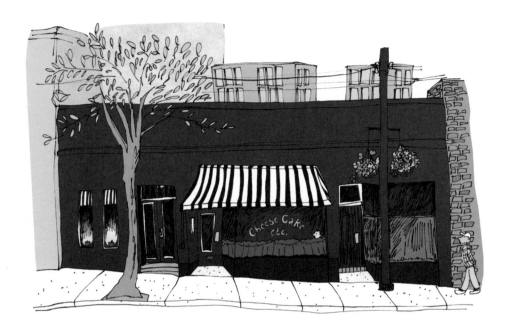

As a child, whenever we went to the airport, I'd peer with curiosity out the car window at the stores and art galleries lining South Granville. One storefront that always intrigued me was Cheesecake Etc. It turns out they serve only cheesecake, and the "Etc." refers to the live jazz that has played there since the café opened in 1979.

A man with his hands behind his back walks up the slope from the Granville Street Bridge, melodious Italian opera streaming from his mouth. It sounds like he should be famous. And he is—within the neighbourhood, at least. Francesco Pepita is fondly known as the South Granville Opera Man.

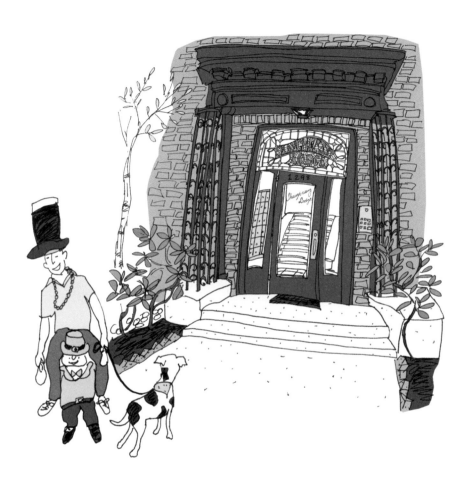

Shaughnessy Lodge is an apartment building on West 10th just east of South Granville. It is St. Patrick's Day, and the bottle-green stained glass window over the door catches my attention. Imagine my surprise to see a leprechaun emerging from the building! Well, at least, an Irishman with a clever costume and a dog.

SHAUGHNESSY

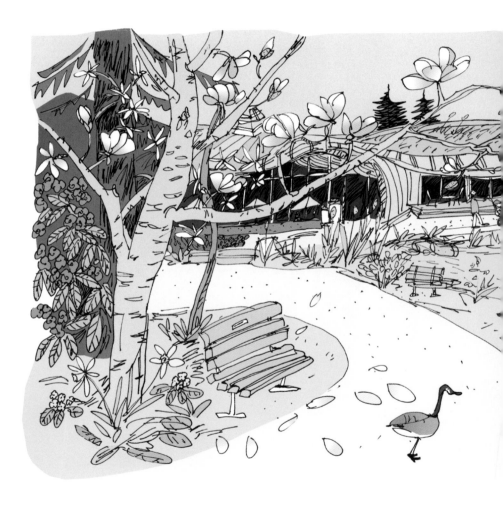

I have to return to the VanDusen Botanical Garden several times before I catch the magnolia trees in blossom, but it is worth coming to these gardens more than once in a season. Finally, I am rewarded with the sweet-scented pink-white blooms I was waiting for.

A house in Shaughnessy hides behind an imposing hedge.

MARPOLE

At Pho'Ever, a Vietnamese restaurant in Marpole, Mona, the owner, encourages customers to help with the decor. People add their drawings and words to the wall with felt-tip pens.

As she serves me a banh mi sandwich, she explains that she had to paint over the lower half of the wall in a dark green after some renovations, losing many of the inscriptions.

An older couple who came to the restaurant soon afterwards were in despair—Mona had painted over their grandson's artwork. He lives in Hong Kong and they don't see him often. "They like to sit beside it," she says, shaking her head. "He'll have to come again soon."

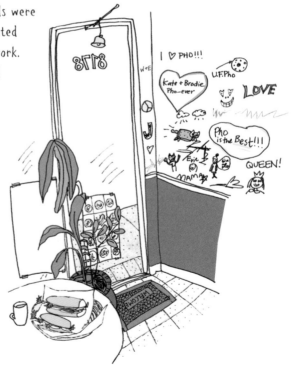

I feel protected under a large cedar tree as I sketch the childhood home of author Joy Kogawa, who was born in Vancouver in 1935. Some drips of rain still make it onto my paper, leaving what look like tear stains. The same tree would have existed in the garden when she played there, as did a cherry tree in the backyard, which is celebrated in her children's book *Naomi's Tree*. But it is *Obasan* that she is most known for, the young adult novel that closely parallels her own story as a young girl. She and her family were taken from this home and brought to the Japanese internment camp in the Slocan Valley twelve weeks after the bombing of Pearl Harbor.

Though Joy never returned to live in the house after the war, her legacy lives on. The writing desk where she wrote *Obasan* is in the front room, and the house now functions as a home for writers in residence.

KERRISDALE

As a solo diner at Asa Sushi, in Kerrisdale, I am privy to some private conversations while I contemplate the bento box in front of me.

"So I've redone my will. With four more grandkids, I had to think about it. They'll each get 2.5 percent."

"When they are how old?"

"When they're twenty-one."

"Isn't that a bit early?"

"Tom thought so. He thought thirty-five. I said heck, we live in Vancouver. Those kids are going to need that money to survive."

"That's true."

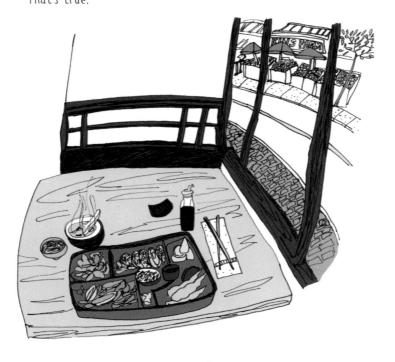

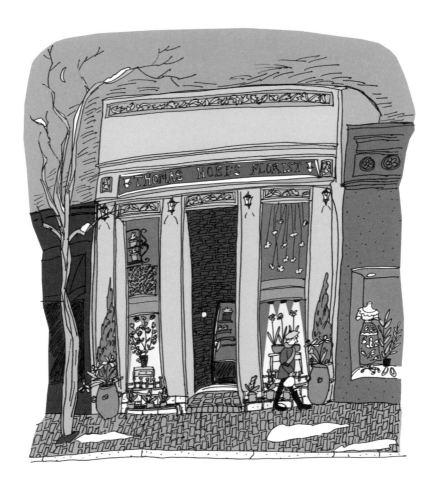

The front windows of Thomas Hobbs Florist and Hill's of Kerrisdale, on West 41st Avenue, do their best to reassure passersby that spring is on its way, despite an unseasonable snowfall. The moon is barely visible, a thin sliver in the evening sky.

DUNBAR

One day I unexpectedly pass Crofton House School, the all-girls school I attended. I am surprised to see the renovations to the Senior School: there is now a whole new building where there once was just ivy-covered stone walls and a wrought iron gate. I walk around the corner to the main entrance on Blenheim Street, not sure what to expect. There I see more renovations in progress. I ask a construction worker what they are doing.

"Oh, we're making it more beautiful. Some new curbs, more landscaping. Beautification, basically."

I nod, not sure what to think, as Crofton was never not beautiful.

"You went here?" he asks me.

"Yeah. Grad 2000."

"Cool. I was '98, from PW*," he responds.

I concede that many years have passed and the school is allowed to make improvements. But when I return to do a sketch, I choose the portion of the wall with the least changes apparent, by the bus stop where the ivy still grows thick.

*Prince of Wales Secondary

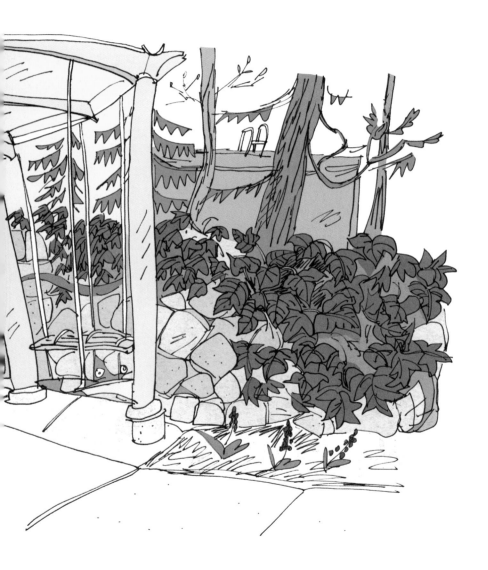

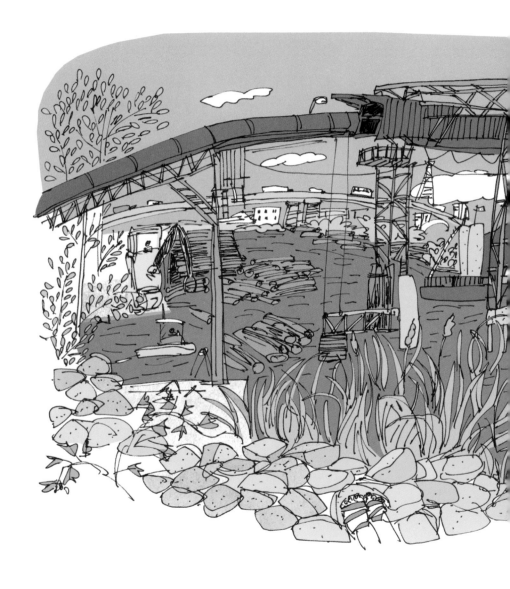

The Musqueam people have a reserve at the mouth of the Fraser River. On a blue-sky day I sit on the opposite side of the river and draw the industrial landscape just east of it. With Richmond's River Road at my back, I recall a text I read at the cultural centre on the reserve. This entire waterway and many more are the ancestral legacy of the Musqueam people, and I realized how little I know when I read these words:

> "Long ago, probably many hundreds of years ago, according to the stories of the old people, this flat country was only water, everywhere just water. There was none of these places that appear today called Garry Point, Terra Nova, and Sea Island. There were none. It was said to be only water, all of it, except for the place over there, on the outer side that is called Point Roberts. It is said that was an Island."
> —James Point, recounting the story of Smelew and Sqalecemas

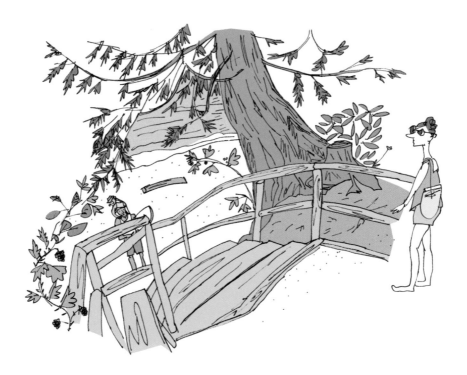

UBC campus has changed so much since I studied here in the early 2000s. It is a relief that Wreck Beach, the clothing-optional beach at the very tip of the campus, is largely unchanged. You can still find lots of bare bums, wild salmon burgers, and the nicest sandbar for skimboarding. Also remaining are the many stairs to get down and up again. I count 502.

Once on the beach, people stake out their own Gardens of Eden in hammocks and even small wooden structures. My favourite place is at the base of the receding cliffs, a little ways around a point.

An airplane takes off into the sky above, reminding me of my first week living in a UBC dorm, when I woke to my clock radio and the news of 9/11. I came down to the beach often in the days that followed, to clear my head. The planes, usually so frequent, were nowhere to be seen, as air traffic ground to a halt across North America.

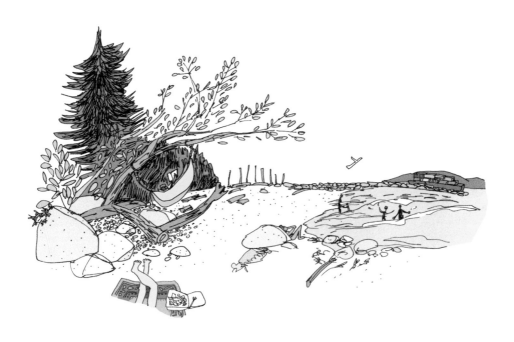

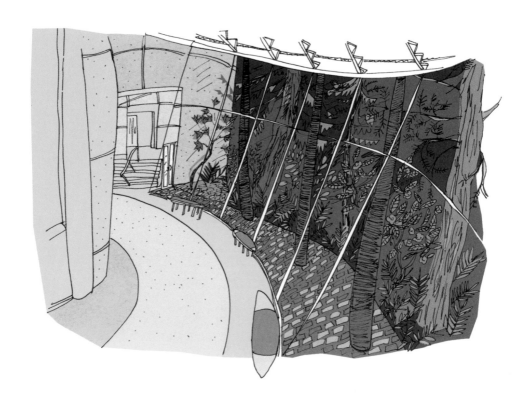

At the Chan Centre for the Performing Arts, on the UBC campus, the
architecture invites the forest inside.

If you go down to the woods today . . . you might find some beer cans and the aftermath of a game of beer pong, evidence of nearby student dormitories.

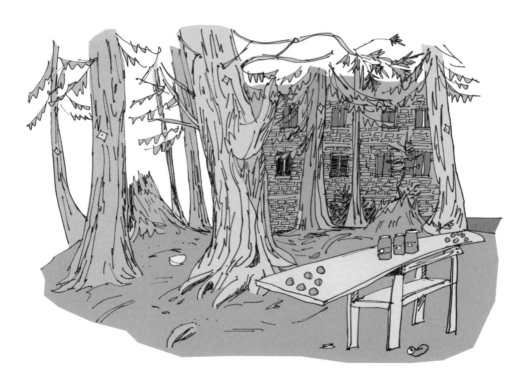

Since 1991, the UBC Botanical Garden has hosted the Apple Festival in the second week of October, bringing families, students, and apple lovers together to celebrate the fruit.

On offer in the tasting tent this year:

Alexander, Alkmene, Blushing Susan, Bramley's Seedling, Chestnut Crabapple, Dabinette, Discovery, Egremont Russet, Epicure, Fameuse (Snow), Fuji, Golden Russet, Gravenstein Red, Grimes Golden, Hansen Crabapple, Hidden Rose, Honeycrisp, Jeffries (or Jefferis), Jonafree,

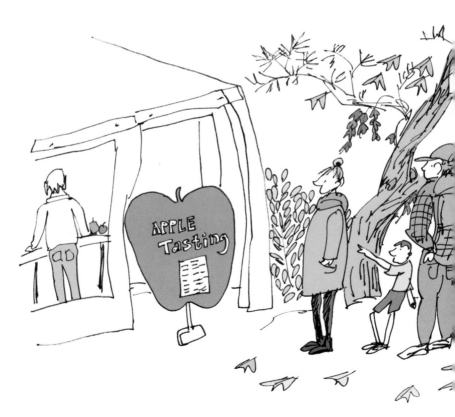

Kerr Crabapple, King of Tompkins County, Liberty, Lodi, Melrose, Northern Spy, Oaken Pin, Pinova, Red Rome, Reinette du Canada, Rosu de Cluj, Rubinette, Saint Edmund's Pippin, Spartan, Sundance, Sweet 16, Tangowine, Vanderpool Red, Wealthy, and Wintercrisp.

And these varieties of cider trees: Chisel Jersey, Dabinette, Kingston Black, Stoke Red, and Yarlington Mill.

Additional kinds were crossed out, as they had sold out by the time I arrived.

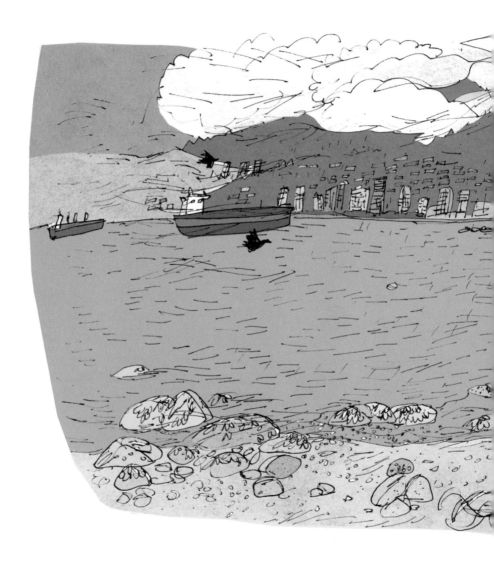

POINT GREY

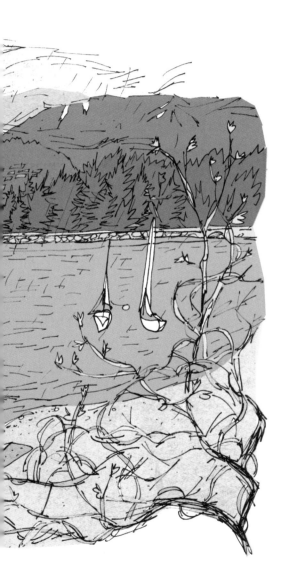

The view from the unofficially named Wilderness Beach, where Kits Beach ends and Point Grey begins, is mostly grey today, except for the Villa Maris apartment building (a.k.a. the Pink Palace) along the West Van shoreline. Two friends in conversation pass by. "I went to Whistler, I came back, and my roommate has taken over the fridge . . ."

I visit Arthur Erickson's house in Point Grey, located at 14th Avenue and Courtenay. The famed architect died in 2009, but Simon Scott, a fellow architect and friend of Arthur's, lets me in the garden gate.

"Arthur took two thirty-three-foot lots, one with a shed on it, another with a garage, and joined them to make his home. There isn't even a bedroom, just a sleeping loft. It was a peaceful, Zen kind of place for him—except for when he had parties, of course."

When Britain's Royal Ballet performed *Swan Lake* at the Queen Elizabeth Theatre in 1967, Erickson hosted an after-party for the show's two stars, Dame Margot Fonteyn and Rudolf Nureyev. Two black swans were also invited; presumably the birds made themselves comfortable in the pond. I wonder if Fonteyn and Nureyev struck a pose on the square moon-viewing platform.

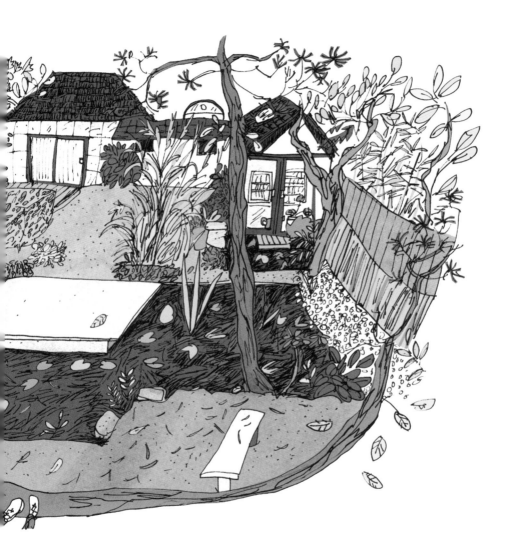

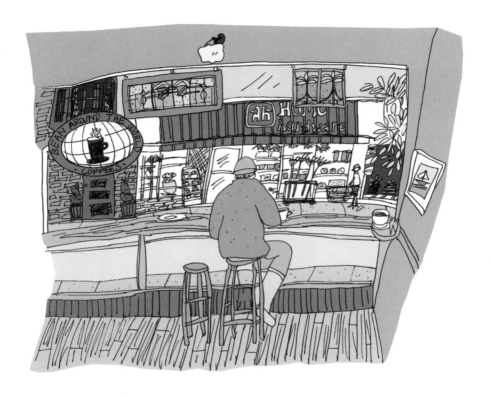

Just around the corner from the house where the environmental group Greenpeace started, Bean Around the World is a locally owned coffee shop, with locations throughout the city, that aims to act local and think global. Today it is two degrees outside and customers are wearing toques. A group behind me dreaming of warm-weather travel discusses the pros and cons of Airbnb.

A novel way to invite the neighbours over: when Nadine Harding was a young mother renting a third-storey apartment on West 1st Avenue, she and her husband would invite the neighbours up for a beer—with a fishing rod baited with a beer can.

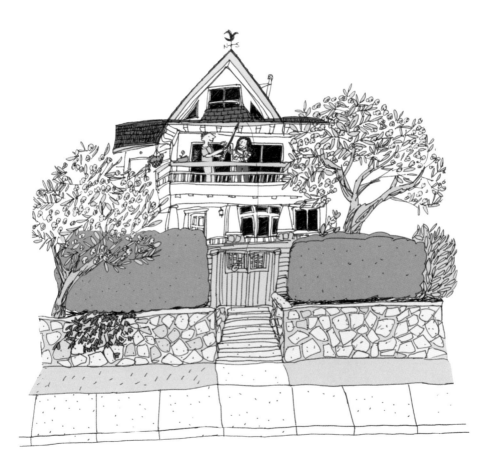

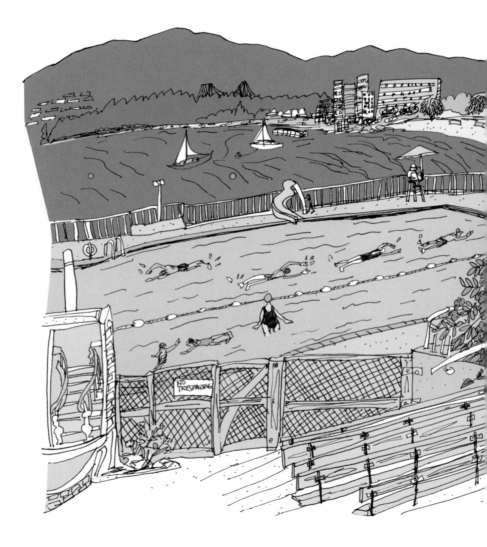

KITSILANO

Kits Pool is the longest in Canada, and its salty water is a joy to swim in. While completing backstrokes along its 450-foot length, I look up. A floatplane skims across the endless blue like a water bug. Seagulls glide closer still; the undersides of their wings are electric, reflecting the pool's turquoise water.

At seven in the morning the pool is calm and collected, and people swim in orderly rows. Others do calisthenics in the amphitheatre overlooking the pool and Kits Showboat stage. By mid-morning, parents—mostly mothers, but some fathers, too—navigate the water with their children in tow. In the evening people arrive from work, filling the lanes with thrashing bodies swimming into the setting sun.

As I gasp for air mid-stroke, I see a man swim by with his locker key latched onto his sunglasses, glinting golden in the light. In the shallow end a woman wearing a sari enters the water tentatively, her husband, also clothed, cajoling her in. It reminds me of another place, the Ganges, and the idea that water might be holy. Beyond the pool, on the ocean, people appear to walk on water, standing upright on paddleboards among the freighters.

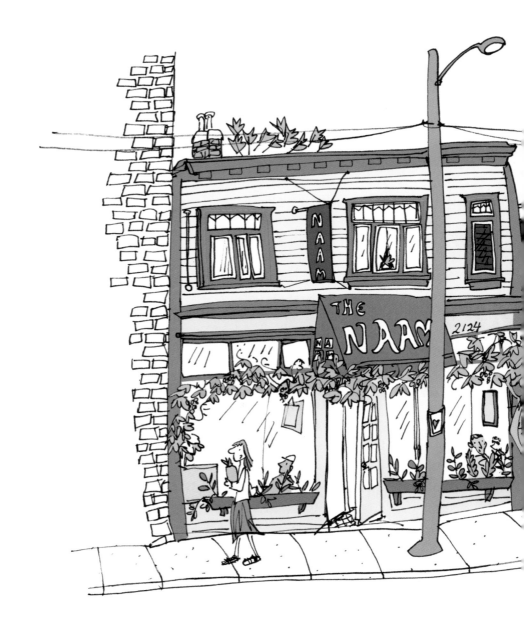

Vancouver's oldest vegetarian restaurant, the Naam, is open twenty-four hours a day every day of the year. As a UBC student, I attended mandala-painting parties in the apartment above the restaurant, and it is there that I learned what chakras are.

Oh, and the food at the Naam? Two words: MISO GRAVY.

At Amethyst Creations, some peanuts are left out on the sign for the neighbourhood crow.

I like to go to this crystal shop after a lunch at the Naam. It always makes me feel I am back in Vancouver, particularly the one time when a young employee told me that "rocks rooock, man." Other times, owner Brian Liu or his daughter Yvonne are there, full of stories about the many rocks in their shop.

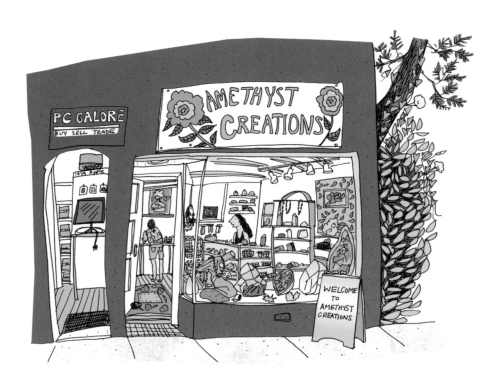

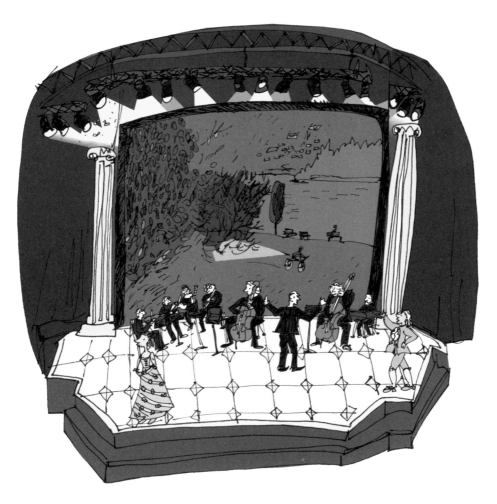

At Bard on the Beach, Shakespeare's plays are enacted with Vanier Park's ocean vista, Stanley Park, and the North Shore mountains as a backdrop. This year, they've added a performance of Rossini's opera *The Barber of Seville*. I draw in the dark, noticing the moths circling the theatre lights. In the distance, a bike light skirts across the shadowy landscape.

Zulu Records, on West 4th, is a case of the record shop saves the video store—the long-time fixture in the music scene absorbed the video store Videomatica when it almost closed down.

Zulu has been in business in Kits for thirty-seven years, but not always at this location. The owner, Grant McDonagh, comes outside to talk to me:

"This building was where they used to make cotton candy for the PNE. Then, in the '70s, you had the underground performance art group Intermedia using the space. Jeff Wall had his first show here back when it was the Nova Gallery! This whole area was a cultural hub. You had the Grateful Dead playing at the Russian Community Centre up the road . . . A lot has changed now. You should draw those brick buildings up the street, they're knocking them down next week. They were built in 1915, like something out of *Coronation Street*."

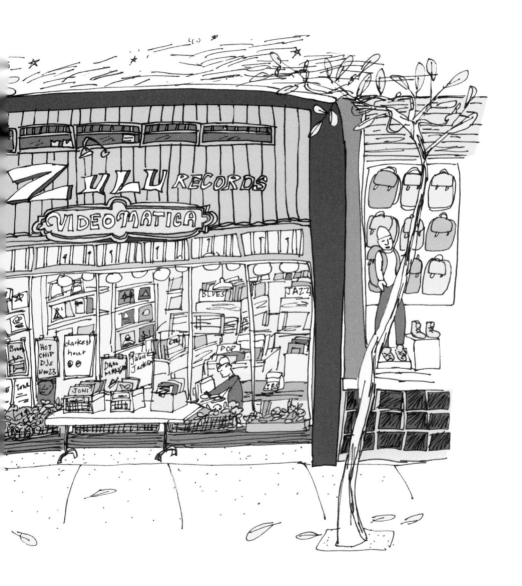

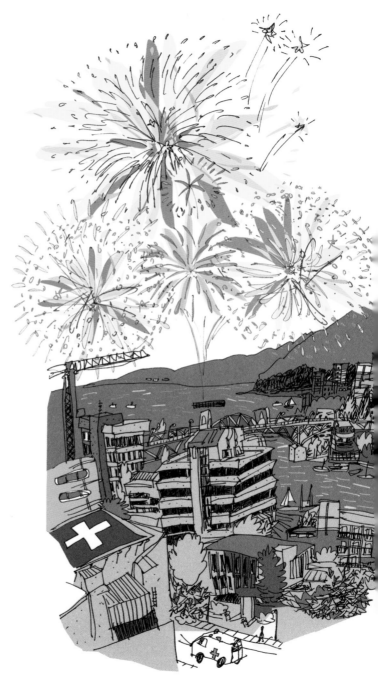

FAIRVIEW

The annual Celebration of Light is a fireworks spectacle that bedazzles the sky, throwing a Mondrian-style boogie-woogie of coloured light onto the windows of buildings in English Bay. Vancouver General Hospital's Intensive Care Unit, where I visited my father during the week of the fireworks, happens to have a particularly good view. Below, on West 10th, the wail of a siren goes unheard under the loud booms of the fireworks show.

On a walk home one evening I am stopped in my tracks by the sunset at Choklit Park. A steeply sloped park that slices through a now residential area, it has an interesting history, recorded for posterity on a plaque:

"Charles Flavelle of Purdy's Chocolates created Choklit Park in 1970 on the unused Spruce Street right-of-way at 7th Avenue, using a crew of six hired on an 'Opportunities for Youth' grant. The chocolate factory at 1107 W. 7th needed an improved truck-loading facility and the children in the neighbourhood needed an adventure playground. The crew used the right-of-way and all the available space around the factory for the children's park. Purdy's made chocolates here from 1949 until 1982." The purposely misspelled "Choklit" is a playful reference to its chocolate history.

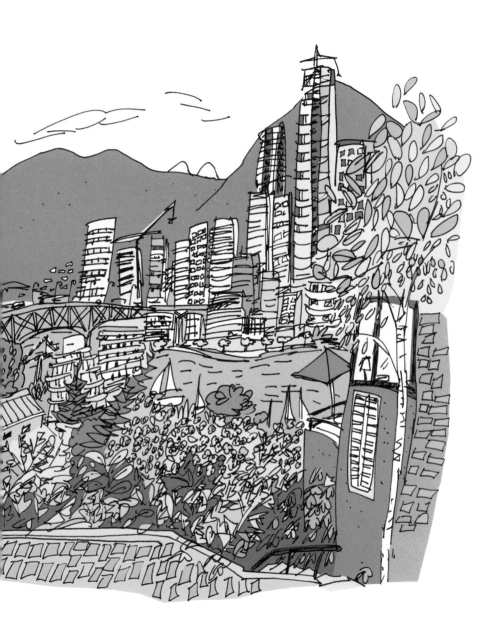

Old homes with porches are inviting places to spend summer afternoons.
An elderly gentleman was my neighbour while I worked on this book.
He and his wife were aging in place while their grown children lived in
apartments within the same house. A caregiver would come each day to
go for walks with him. I'd see them sometimes on a street corner debating
their route. "Well, we haven't gone this way in a while," one would say.

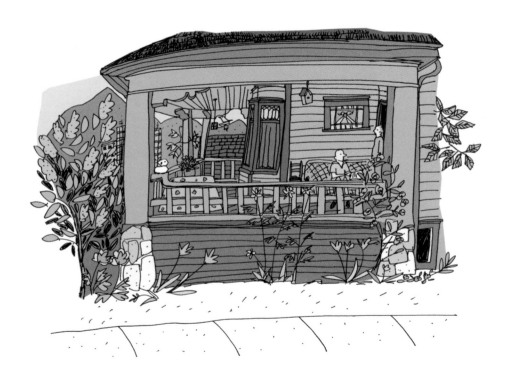

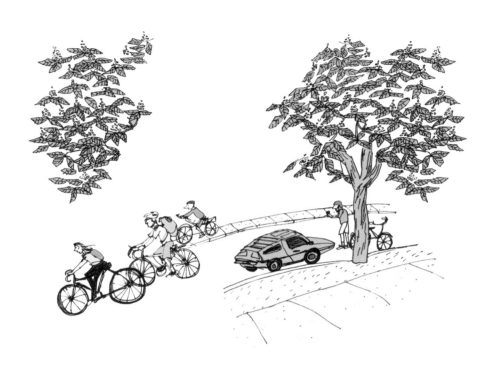

West 10th Avenue is lined with many heritage houses, low-rise apartment
buildings, churches of various denominations, and also chestnut trees.
They blossom in the spring and provide leafy shade all summer. In the
autumn, the chestnuts fall and can be a hazard for joggers and cyclists.
The street is otherwise a haven for bikers: half a million people cycle the
east-west bikeway each year.

Overheard on West 10th: "I find Vancouver suspiciously spacious. I'm
used to the alleyways of Manhattan."

CAMBIE VILLAGE

Cambie Village is a friendly assortment of shops and cafés, anchored by stalwart neighbourhood institutions like the Kino Café and the Park Theatre, a small movie house. BierCraft Bistro and a barber shop share digs on the corner of Cambie and 17th.

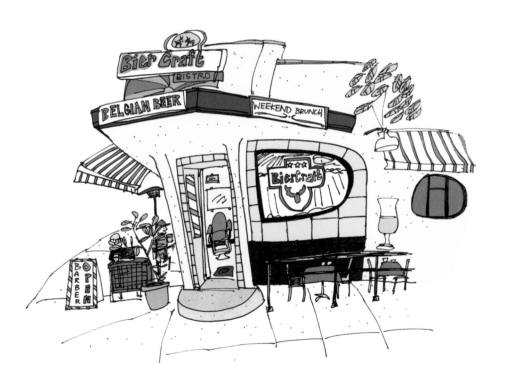

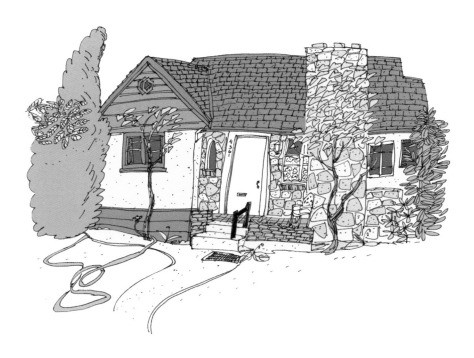

4361 Cambie Street is one of many houses along the "Cambie Corridor." My friend Naomi lives there now. She is the granddaughter of long-time residents of the house, Moses and Esther Steinberg. However, she rents the home from the new owners, knowing it will be demolished someday to make way for new developments. Moses was a respected professor of literature at UBC, and he and Esther were active members of the Jewish community. In the interests of preserving history, nine boxes have gone to the UBC Archives and two boxes to the Jewish Museum and Archives of BC.

OLYMPIC VILLAGE

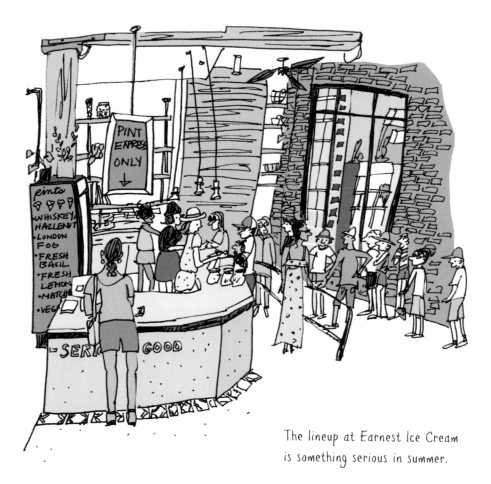

The lineup at Earnest Ice Cream is something serious in summer.

The workshop window at AB Scale Models, on 5th Avenue, is a study in towers.

Inside, there are models galore. Ming Yang has run the shop for forty years. He got his start when he was sixteen, working under a master model maker in his home country of Malaysia. At the time, Arthur Erickson was in the country and got him working on a project that eventually led him to Vancouver.

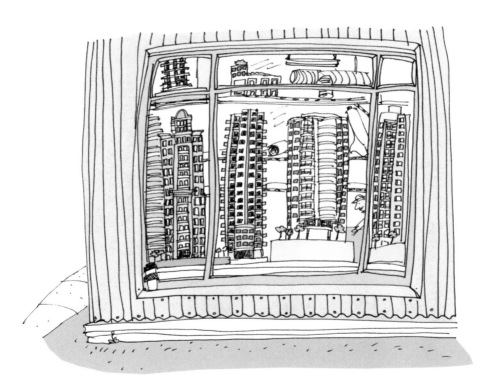

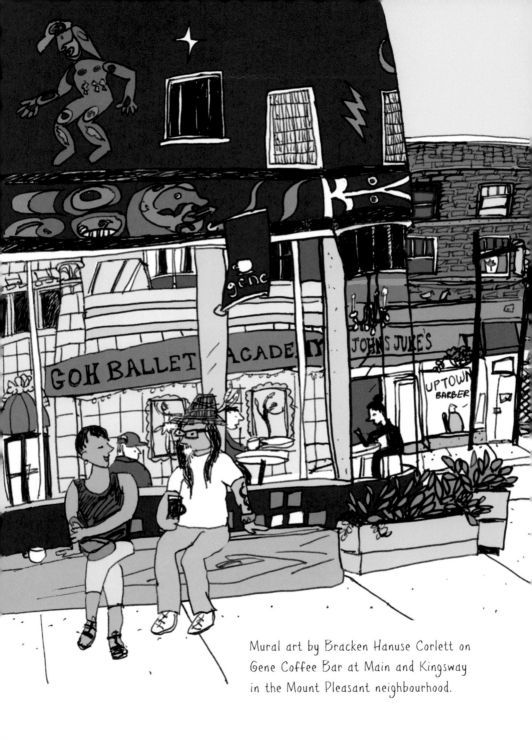

Mural art by Bracken Hanuse Corlett on
Gene Coffee Bar at Main and Kingsway
in the Mount Pleasant neighbourhood.

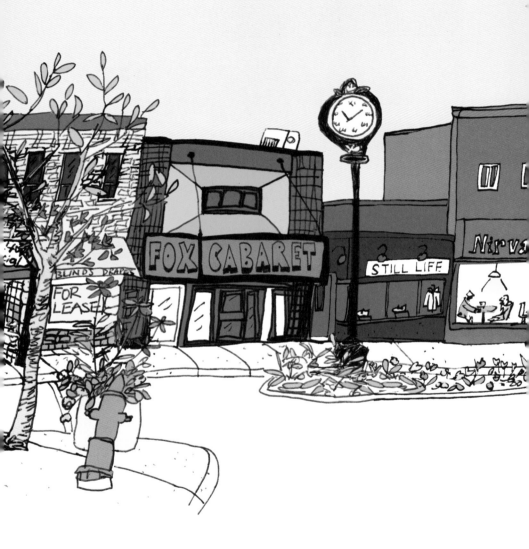

EAST SIDE

the FRASERHOOD

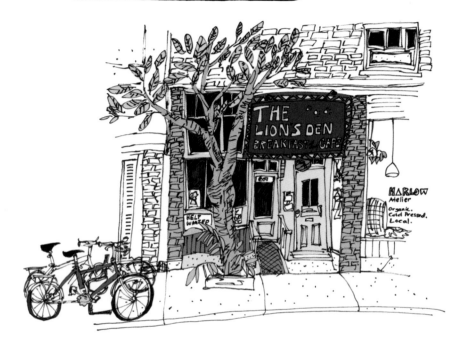

In the Fraserhood, the Lion's Den Café is home to Caribbean and Japanese food, reflecting the heritage of husband and wife Ken Brooks and Junko Tanabe. They also host occasional "Soul Food" parties, where they serve up Southern fare. Junko has been the cook for the past eighteen years, and Ken made people feel at home with stories and jokes. Sadly, his voice was silenced by a stroke in recent years, but his broad smile and thumbs-up through the window when I show him my drawing speaks volumes. I am told that in lieu of saying goodbye to customers he used to say, "Have a creative day."

Le Marché St. George, a café and general store in a residential neighbourhood, was at risk of being closed down over a bylaw issue that prevented them from serving food, even though they had commercial zoning. The city had a change of heart after the many people who love the corner café rallied and 15,246 people signed a petition for it to stay. I am oblivious to this as I sit and sketch, but the owner comes out and recounts the story. "You know how people talk about things going viral? Well, that's what happened. It was incredible."

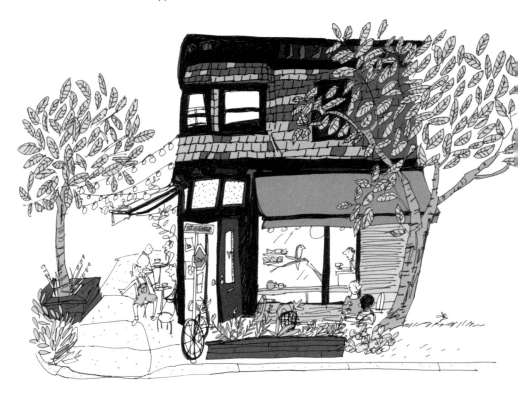

RILEY PARK

Lilies tower six feet high and demand
attention at this Riley Park corner.
A woman stops to take a photo.

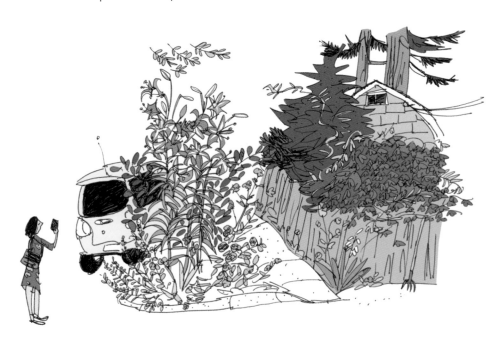

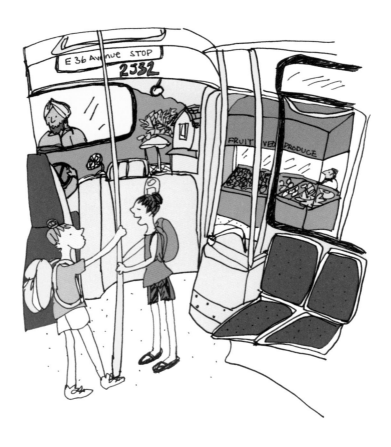

These little ballerinas are headed to class at the Goh Ballet Academy. They talk *Nutcracker* rehearsal schedules while they take the bus down Main Street.

I sketch Helen's Grill, Windsor Meats, and Book Warehouse with a belly full of Southeast Asian food from Hawker's Delight, my favourite hole in the wall on Main Street. So unfortunately, I don't have room to try the dessert offerings at Helen's, which has been a fixture in the neighbourhood since the 1950s. The Yelp reviews have this to say:

"It's all about the nostalgia. Nothing fancy, just decent grub. There are similar places like this of similar quality for less. But Helen has the trump card—the little mini juke machines per table."
—LAURA L.

"Just remember the booths were built 50 years ago when waistlines were smaller!"
—GEOFF G.

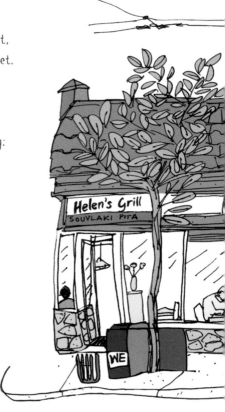

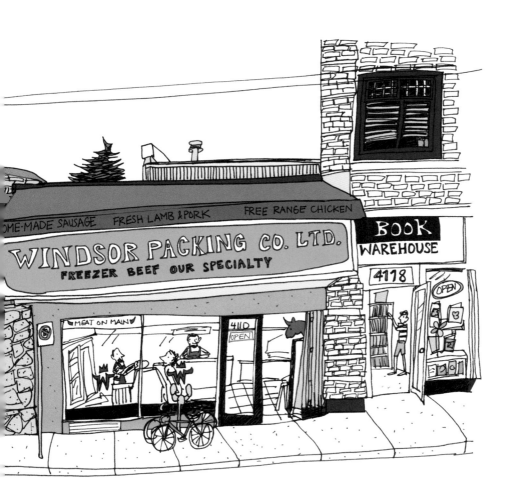

LITTLE INDIA

This small, unassuming house at 48th and Main has a dazzling garden. The house is in the area known as Little India or Punjabi Market, home to many East Indian residents and commercial stores dealing in bright fabrics and Indian foodstuffs. But most of the houses on this block are for sale, and in Vancouver that means that they will soon be gone.

I get up the courage to knock on the door. A man answers, and I ask if I can draw the house. He says no, but I can draw the garden. That is what I was most interested in, anyway, and I sit on his stoop and get started.

He joins me and I ask him how he feels about the neighbourhood changing. He shrugs and says, "Who knows if it is good or bad?" I ask what restaurants are good for eating in. "You know, actually, we don't eat in restaurants. I prefer the food we cook at home. Here we grow most of what we need—potatoes, garlic even. The zucchini is not doing well, though. The flowers—they are for praying with." I can smell delicious curry that is being prepared within.

As I finish, he strides into the garden. "Would you like some kale? It is good in smoothies." He hands me some, along with an eggplant, and a green chili, too. I am touched and say thank you. I gesture to the small elephant, Ganesh, over the doorway. "Oh, that is for *vastu shastra*, to give us luck."

I look it up when I return home. As part of the belief, it is thought that every piece of land or building has its own soul.

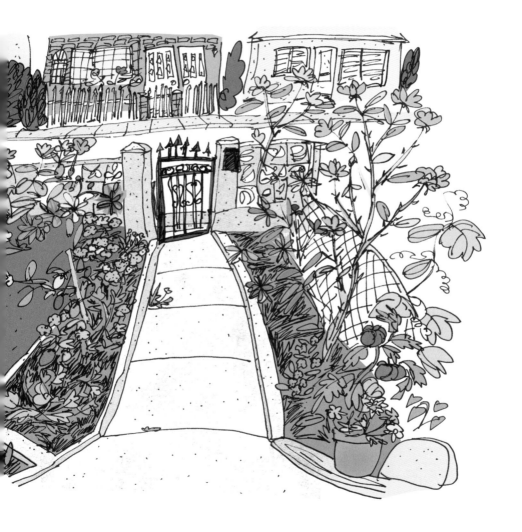

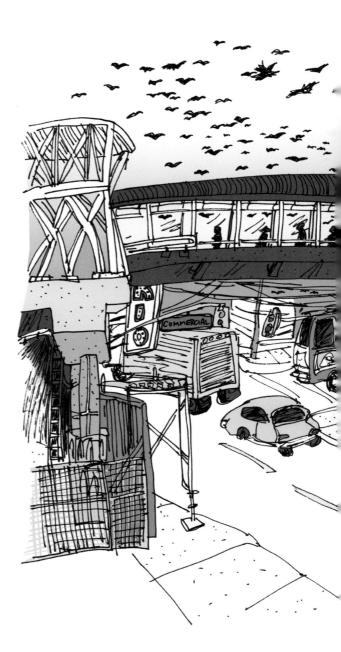

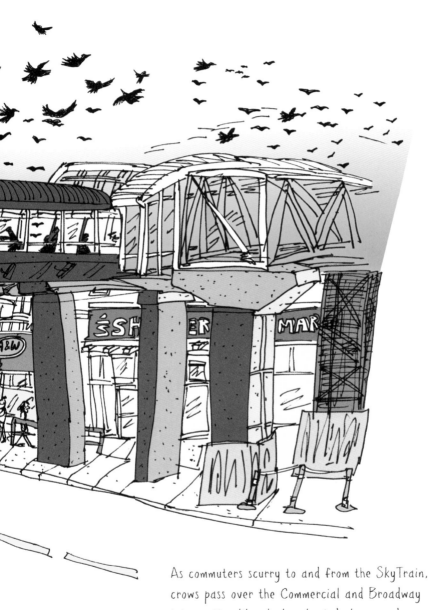

As commuters scurry to and from the SkyTrain,
crows pass over the Commercial and Broadway
intersection like clockwork at dusk every day.

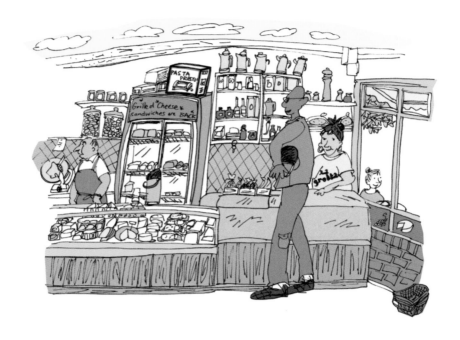

Just up the Drive, at 1791 Commercial, is La Grotta del Formaggio, an Italian deli where sandwiches are made fresh from the finest ingredients. It is the kind of place where staff know the regulars. A tall man with his motorcycle helmet under his arm says, "Darling, it has been too long," with a laugh that suggests the opposite is true. More laughter when his cheese is rung through. "$6.66—that is devil's cheese!"

Owner Fortunato Bruzzese is behind the counter, keeping the sandwich line moving and making orders on the phone. "I'll need seven cases of cheese curds. Camembert, two cases. Cheddar, I have enough."

At the corner of Clark Drive and East 6th Avenue, artist Ken Lum's "Monument for East Vancouver" (commonly known as the East Van Cross) takes local graffiti and turns it into a welcome sign for the area.

People gather at Britannia Secondary School to rehearse for a *Thriller*-themed flash mob at the Parade of Lost Souls, the neighbourhood's nocturnal Halloween celebration.

Kat Single-Dain took over the event from the Public Dreams Society. Now, she not only oversees the entire parade but spends the weeks leading up to the big event teaching Michael Jackson's zombie-like choreography to the flash mob.

"Let's just do a thirty-second warm-up to start. Do whatever you need to get your blood pumping—even though that's a bit ironic. Don't forget, we're trying to become zombies."

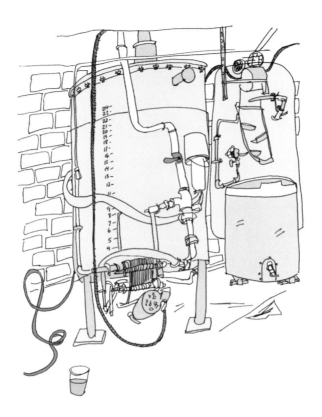

Storm Brewing, at Commercial and Hastings, has the title of Vancouver's first craft brewery, founded in 1994. It's hard to believe there was ever only one, as new breweries appear seemingly overnight throughout the Lower Mainland. On a Friday night, bikes pile up outside, and people press close to the bar to taste the latest brews. Today's refreshing offerings include a beer made with watercress that was grown and juiced by brew master James Walton. James also rigged up the still himself, repurposing a hot tub!

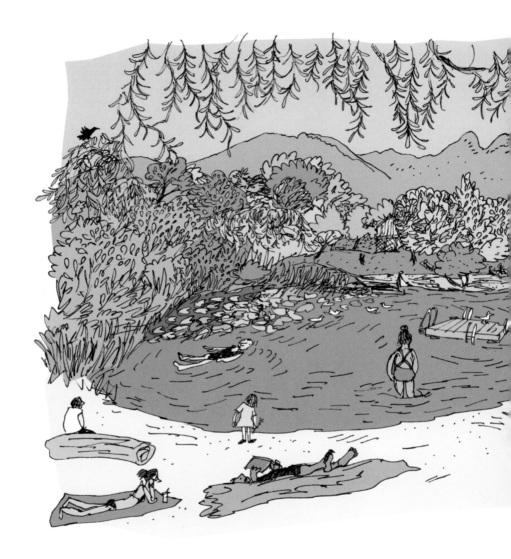

Summer is cresting and will soon be over, but people take advantage of any chance to be near water, including the beautiful Trout Lake, in East Van. While sketching the popular swimming hole, I run into a friend I haven't seen since high school. Her young son crouches close to me in that familiar way that kids of a certain age do.

"How do you draw the wind?" he asks.

"A very good question," I answer, as a warm breeze fans the surface of the water.

STRATHCONA

The Chan House is a significant building in Strathcona, Vancouver's oldest neighbourhood. Former residents Walter and Mary Lee Chan stood up against "urban renewal" projects in the 1960s, when there were plans to raze houses to make way for a freeway through downtown.

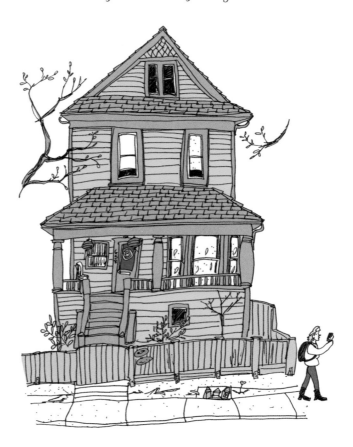

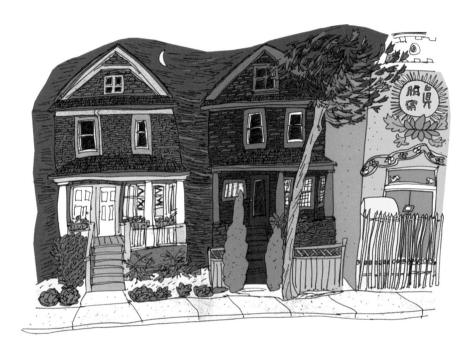

In Strathcona, houses and Buddhist temples exist side by side. On a warm
night, a monk locks the gate of the PTT Buddhist Society, on Keefer
Street, and I stop to listen to the sounds of the street. I hear kids
playing basketball behind me in the Strathcona Elementary schoolyard,
and the laughter of old men as they walk together, speaking Cantonese. A
grandmother walks by me, her cane tap-tap-tapping on the sidewalk. Her
young granddaughter speeds ahead in a pair of sparkly purple shoes.

HASTINGS SUNRISE

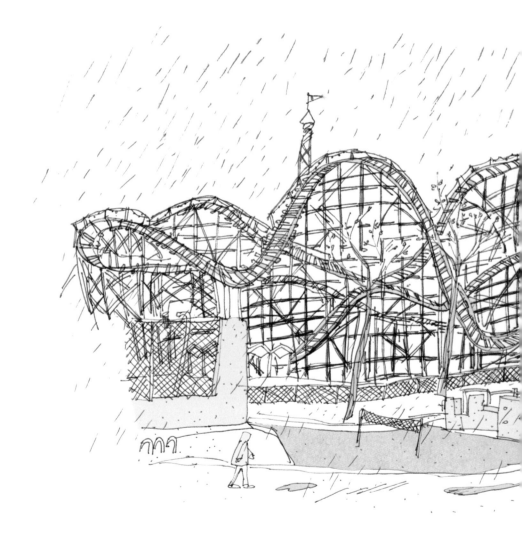

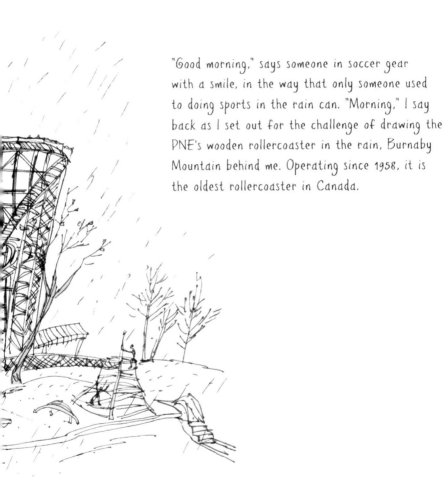

"Good morning," says someone in soccer gear with a smile, in the way that only someone used to doing sports in the rain can. "Morning," I say back as I set out for the challenge of drawing the PNE's wooden rollercoaster in the rain, Burnaby Mountain behind me. Operating since 1958, it is the oldest rollercoaster in Canada.

On the night before Christmas Eve, snow blankets the baseball field of
Clinton Park. A half-hearted hammering can be heard from a building
wrapped in scaffolding. The North Shore mountains have been open
for skiing and snowboarding for several weeks, and the groomed ski hill
appears as a bald patch on Grouse Mountain.

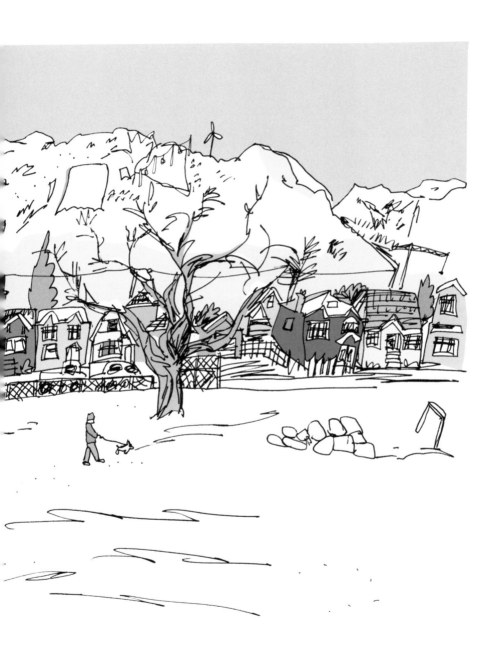

THE
NORTH SHORE

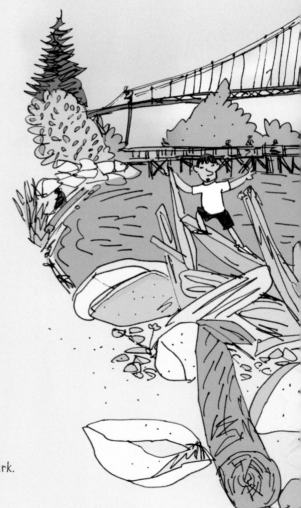

The beach at John Lawson Park.

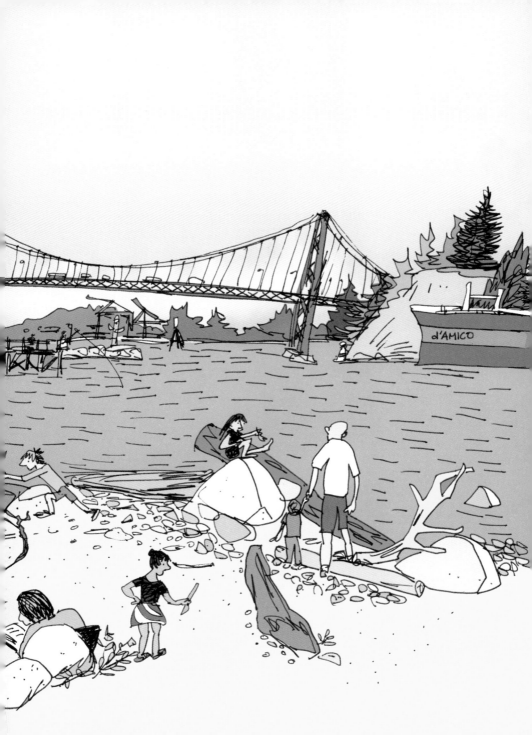

DEEP COVE

At Deep Cove I can see Women on Water in the distance. WOW is a group of women who meet weekly through the summer months to kayak in the evenings. From a distance, they make for a multicoloured flotilla.

Some people jump from the dock. "You know, it's the last day of summer today, but remember, we gotta keep doing this until November." The cold-water plunge is obviously part of their routine.

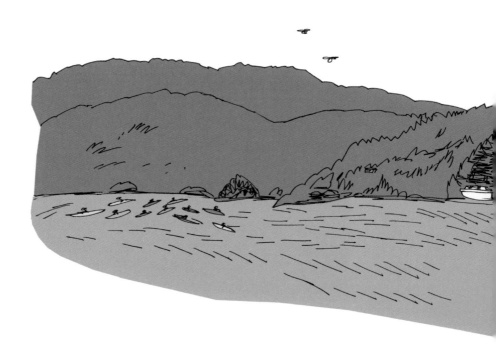

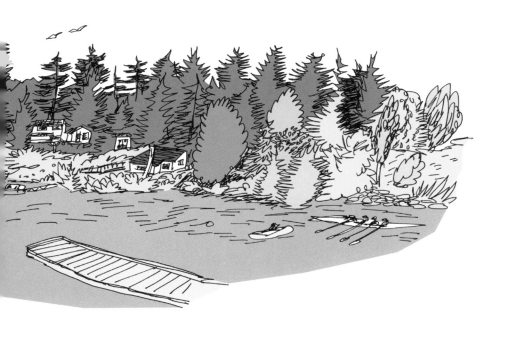

LOWER LONSDALE

The SeaBus running from downtown to Lonsdale Quay is the most scenic way to get to the North Shore. A group of Mexican ESL students speak in English. While checking their phones, they make plans for the rest of their time in BC, including a trip to Whistler.

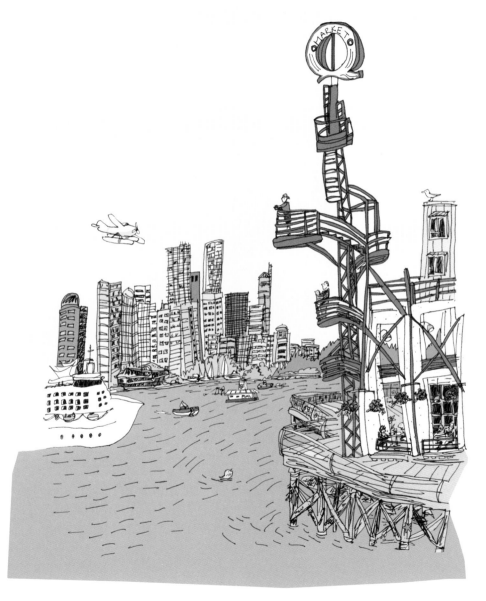

LYNN VALLEY

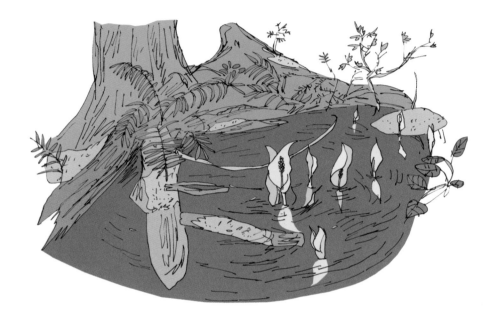

In springtime, skunk cabbages grow in forest pools like this one in Lynn Canyon Park, just steps from the canyon's suspension bridge. Easy to spot because of their bright colouring, they were used medicinally by Indigenous peoples to treat respiratory conditions such as tuberculosis and asthma. Their broad leaves were used to wrap food.

Incredibly, they also produce heat, raising their temperature to allow for early pollination, to protect themselves from frost, and to attract more insects to their skunky odour.

The Harmony Mountain Singers sing their hearts out under the direction of Karla Mundy in St. Clement's Anglican Church, Lynn Valley.

A sense of community is found in choirs, whether it's a mostly middle-aged choir like this one or a choir of young hipsters in East Van. It is through choirs that people find out about a great new apartment for rent, get added to a meal train to support a new mother, or find someone to drive them to their chemo appointment. As of 2016, BC had more community choirs per capita than any other province.

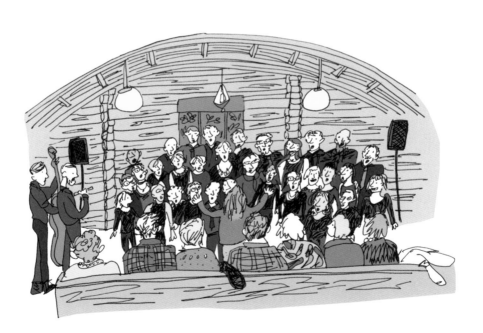

EDGEMONT VILLAGE

32 Books, in Edgemont Village, is decked out for Valentine's Day. A woman passing by says, "It used to be down the street. When it moved, I often wondered if it would do well, but it sure has!"

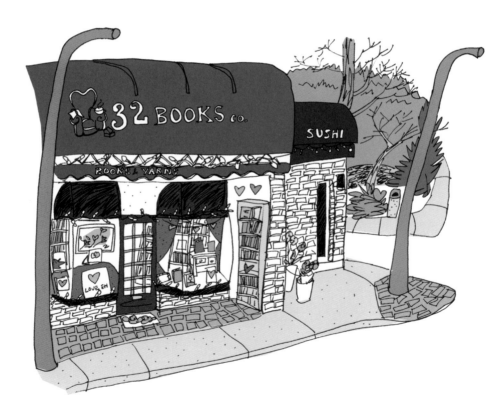

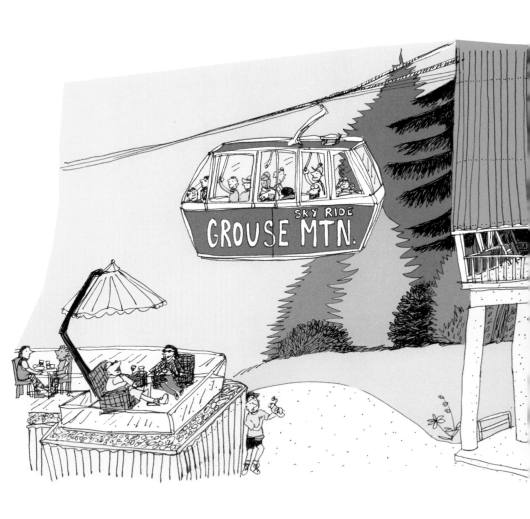

Taking the Grouse Mountain Skyride gondola up the mountain is like a visit to the United Nations; many languages are spoken at once. On my trip back down the mountain, the shared language is sweat, spandex, and sneakers. Regulars on the "Grouse Grind" hike up the mountain on foot, and descend via the air.

PARK ROYAL

Laughter rings out from the other side of the river, where people are fishing on the Capilano Indian Reserve. I can smell the aroma of blackberries, overripe and starting to rot. Farther in the distance I can hear the trundle of traffic on the Lions Gate Bridge.

A man joins me on the riverbank. "Oh, you're interested in the fishing weir, are you? I built most of this," he says, gesturing to the circular pools formed by rock walls that allow him to trap salmon and fish them with a net.

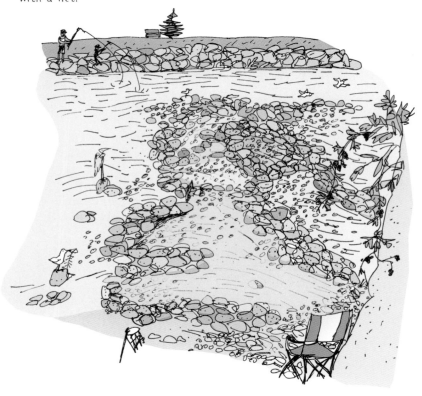

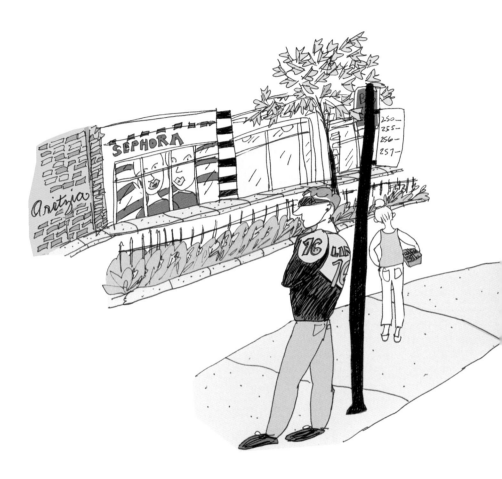

"Are you doing math?" asks a young boy on the bus bench as I write the number 16 on a blank page. We are both waiting for the 250 bus at Park Royal Shopping Mall in West Vancouver. When it opened in 1950, it was the first enclosed shopping mall in Canada.

"OH, you are drawing that guy," he says.

"Yes," I reply. "He is wearing the old Vancouver Canucks jersey, from when the colours used to be orange and black. Trevor Linden wore number 16 in 1994, when I was in Grade 4. The Canucks made it to the Stanley Cup finals that year."

AMBLESIDE

The inscription on a bench in the Argyle community garden in Ambleside reads, "Stop and listen to the grass grow." It isn't just grass growing here—there are also many vegetables and flowers.

I can hear a woman on the phone. "I read about it in the *North Shore News*. Sounds like council is going to listen to you after all. You must be so pleased. Oh, you didn't see it? I'll clip it out for you."

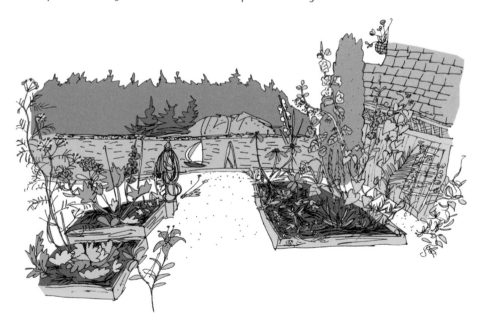

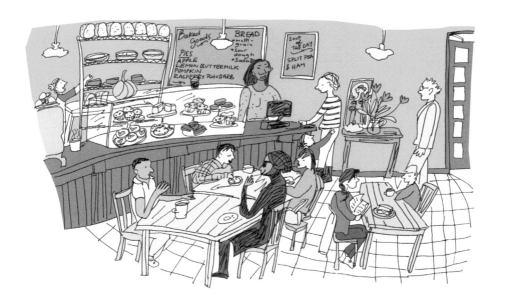

Savary Island Pie Company had various homes when I was a child. The smells and tastes of the baking at each location imprinted themselves on my memory. However, it has clearly found a good home at its current address on Marine Drive, where it is still serving delicious baked goods. Lemon buttermilk pie, anyone?

DUNDARAVE

Christmas trees line Dundarave Beach in December, each tree decorated by a different community group. The trees mark the end point of the West Van Seawall, a beautiful walk no matter what the weather is doing.

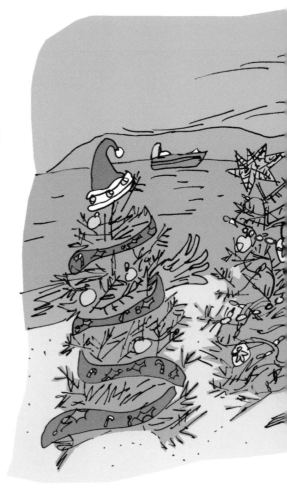

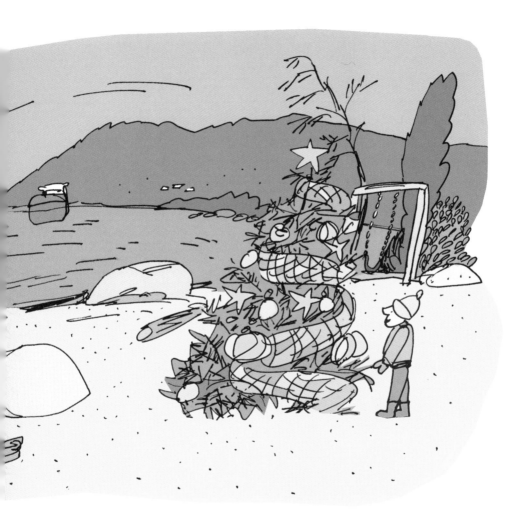

The Hurst family home in Dundarave has always been a musical place, and it's where I learned piano, walking up the back lane to get there. When I visit Mrs. Hurst many years later, she says,

"Oh heavens, you're writing a book about Vancouver. It has changed so much since I moved here. Well, that was in the '50s, after the war in England. The city was a nice quiet little town, five hundred thousand people, as I remember. And Dundarave, it was very different. There were some odd stores. There was a chap who made toys, and a house that sold kittens—oh no, it was puppies. Downtown you'd go to Oscar's Steakhouse. It was rather smart." Oscar's was located at West Georgia and Burrard. I later learn that the attached Palomar Dance Hall played host to musicians like Duke Ellington and Louis Armstrong.

Mrs. Hurst's piano has a story, too. It was built in London in 1916 for a cousin of her mother. The cousin lived in the Schumann household for several years and studied with Clara Schumann, who was known to take on protégées and have them live with her in exchange for odd chores. In 1968 it was shipped to Canada, where generations of young people have learned scales on it, and every December it becomes the centrepiece of the neighbourhood Christmas party.

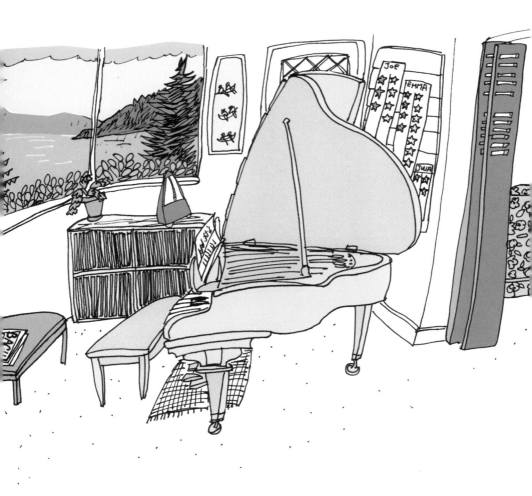

CAULFEILD

In West Vancouver, you can find formal gardens in lush backyards, and old-growth forest in Lighthouse Park.

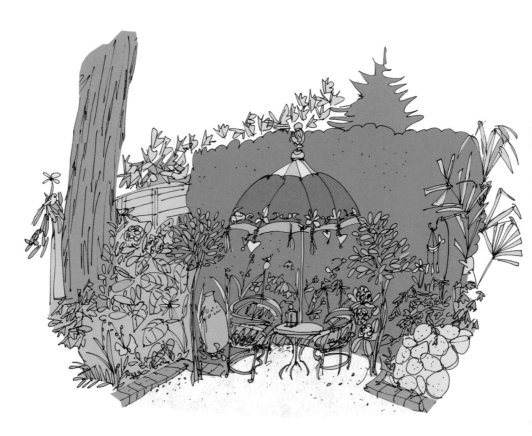

The entranceway to St. Francis-in-the-Wood, an Anglican Church nestled along the curve of South Piccadilly Road, usually marks a sure place to experience peace and quiet. Today, newly graduated high school students whoop for joy and splash into the water in nearby Caulfeild Cove.

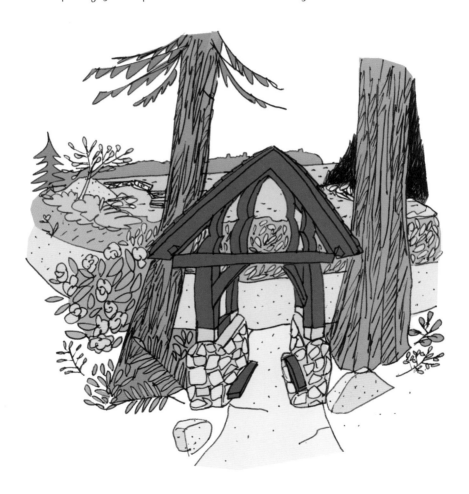

HORSESHOE BAY

Lalli Loves It is a vintage store with a lot of heart in Horseshoe Bay.
According to the owner, Laura: "I had all sons. This shop is my daughter!"

Missed your ferry? Not a problem—head to Troll's. Located a stone's throw from the Horseshoe Bay ferry terminal, the restaurant serves up fish and chips and comfort food to locals and ferry passengers. Joe and Dorothy Troll, two-time lottery winners, opened the restaurant in 1946, catering to local fishermen.

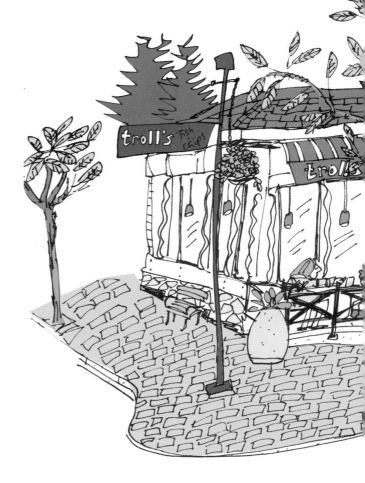

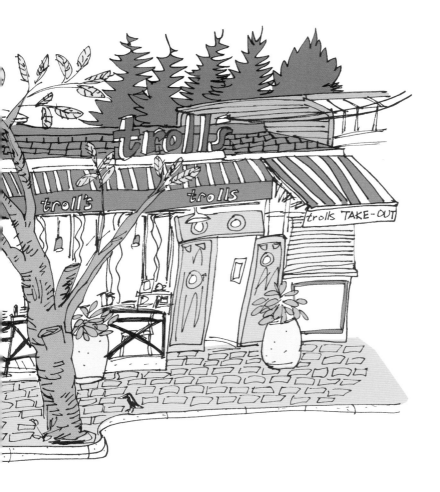

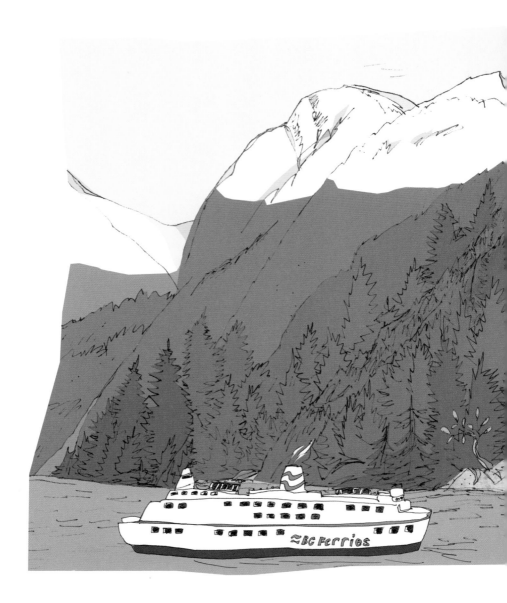

Horseshoe Bay is home to one of two ferry terminals in the Greater Vancouver area (the other is in Tsawwassen). The ferries appear to lodge themselves within the village before heading back out to open waters. The lineups of cars waiting for their ferry wind up the highway, while foot passengers laden with luggage idle near the terminal. There is a feeling of expectation in the air—it feels like adventure is afoot, even if the destination is only Bowen Island, an easy thirty-minute day trip from the mainland. New places to discover, and sketch, await . . .

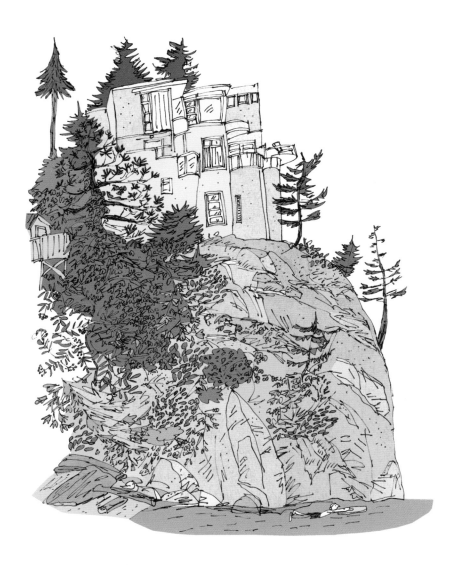

Near the Sea to Sky Highway, houses appear to grow out of the cliffs like barnacles. Small coves below fill with summer swimmers.

ACKNOWLEDGEMENTS

A big thanks to Robert McCullough, the Appetite team, Kristin Cochrane, and Penguin Random House Canada for believing.

Sincere thanks to Lindsay Paterson and Lindsay Vermeulen for your thoughtful editing. Thank you to Rachel Cooper and Jennifer Lum for your careful design, and to Meghan and Meredith Bangay for laying the groundwork for it.

Thanks to the readers, and the people who continuously make Vancouver what it is.

Thanks to Formac Publishing for *Hand Drawn Halifax* and the books that followed. Thank you Creative Industries Nova Scotia for financial support.

Kiriko Watanabe, Geoffrey Erickson, Simon Scott, Ann-Marie Metten, and Lama Mugabo opened doors. Equinox Gallery and Grunt Gallery fielded questions, and Jim Kew of the Musqueam First Nation generously advised on protocol.

Thanks to Seamus Sullivan for the perfect sublet! Naomi Steinberg's "Generative Nest" was a weekly touchstone.

For inspiration during formative years: Gina Leon, Heather Horsley, Daphne Beams, David Bouchard, Fiona Cantell, Lyn Nobel, Elizabeth Hurst, Anna Wyman, Neil Wortley, Danielle Clifford, Pamela Slater, Cornelia Oberlander, Kat Single-Dain, Rachel Wong, Jeremy Todd, Ben Reeves, Gu Xiong, Y, Marina Roy, Barbara Zeigler, Ken Lum, Allison Chase, Hornby Island, Michael Katz, Urban Sketchers, and many more . . .

Mark FitzGerald motivated my ten-month return to BC, while Trish FitzGerald helped me find Appetite. I am grateful for my siblings: Laura, David, and Jeff. The support of my friends means so much—thanks for everything!

Appetite by Random House and colophon are registered trademarks of Penguin Random House LLC.

Library and Archives of Canada Cataloguing in Publication is available upon request.
ISBN: 978-0-14-753120-9
eBook ISBN: 978-0-14-753121-6

Illustrations by Emma FitzGerald
Book and cover design by Rachel Cooper and Jennifer Lum
Printed and bound in China

Published in Canada by Appetite by Random House, a division of Penguin Random House Canada Limited.

www.penguinrandomhouse.ca

10 9 8 7 6 5 4 3 2

appetite | Penguin
by RANDOM HOUSE | Random House
| Canada

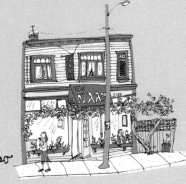

Kitsilano

Shaughnessy

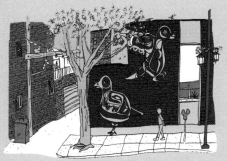

Downtown Eastside

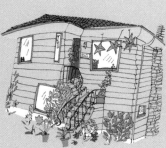

Ambleside

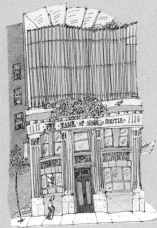

Downtown

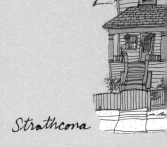

Strathcona